art in wales
2000BC–aꝺ 1850

T0079990

ISBN 0 7083 0620 9 (CASEBOUND)

ISBN 0 7083 0674 8 (SOFT COVER)

© the welsh arts council and

the university of wales press

and authors, 1978

designed by steve storr

text setting by compugraphic,

PPR printing, london

printed by CSP printing of cardiff

Art in Wales 2000BC–AD 1850

An illustrated history
Edited by Eric Rowan

Welsh Arts Council
University of Wales Press
Cardiff

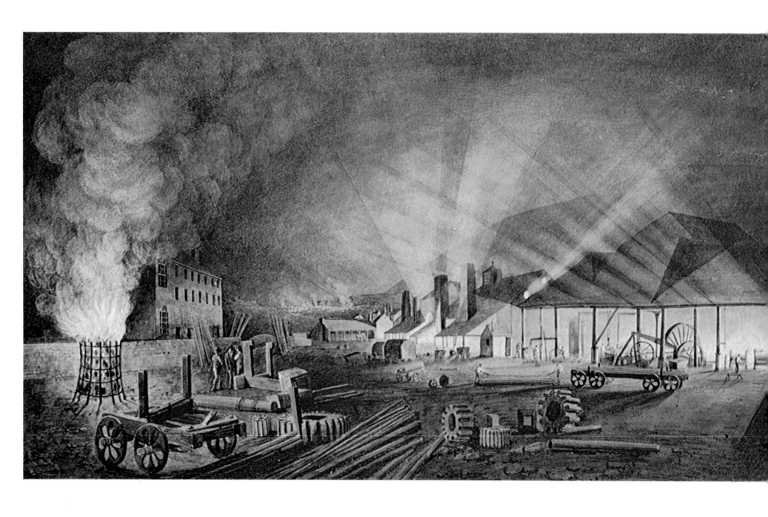

Thomas Horner : Rolling mills at Dowlais 113

foreword

The Reverend Eli Jenkins, that redoubtable caricature of a Welsh divine has pronounced that we are a musical nation. His creator, Dylan Thomas, has left the world in no doubt that we have a great respect for words. Giraldus Cambrensis reported ages ago that we had a talent for music. Our distinguished literary tradition, extending over fourteen centuries, leaves no doubt that language had and still has a dimension far beyond that of ordinary communication. But we have been slow to recognise the variety and dignity of our visual traditions. This publication, the first joint venture by the Art Committee of the Welsh Arts Council and the University of Wales Press is, therefore, a gesture of faith. In order to recognise the capabilities of the present, it is essential that respect is accorded to one's origins, no matter how mysterious, distant or diverse. In this book are celebrated some of the peaks of achievement during a period of four thousand years. This establishes for the first time the dynamic roots from which our visual sensibilities have grown. It demonstrates to the world, and reminds us, that we have much to be grateful for.

We express our thanks to the editor, the contributors, the designer and the printers and in particular to all those who have helped us to share with a new public the visual record of the past.

Peter Jones,
Art Director,
Welsh Arts Council

R Brinley Jones,
formerly Director,
University of Wales Press

St Davids Day, 1978

contents

introduction

This volume, which is the first of two covering the history of the visual arts in Wales, began life as the catalogue to an exhibition. The exhibition— *Art in Wales, A Survey of Four Thousand Years to AD 1850*—was held at the Glynn Vivian Gallery in Swansea, to coincide with the Royal National Eisteddfod of 1964; it was arranged by the then Welsh Committee of the Arts Council of Great Britain in co-operation with the Swansea Borough Council.

The catalogue, edited by John Ingamells, was comprehensive and informative; it represented the scholarship of specialists in each period and was the first publication to cover such a subject systematically. For thirteen years, in spite of the limitations of its original functions as a catalogue, this little publication remained the only comprehensive history of the visual arts in Wales.

Accordingly, the Welsh Arts Council (the autonomous successor to the Welsh Committee) approached the University of Wales Press with the suggestion that the original catalogue could be modified, modernised, extended and published as a first volume in a new history of art in Wales. Recent discoveries and up-to-date information could be included and a greater range of objects, beyond the limitations of an exhibition, could be illustrated. The University Press willingly agreed to co-operate and it was decided that, in order to retain the breadth of interest of the original exhibition, this volume should be amply illustrated and directed towards a lay audience as much as to a scholarly one.

Detail of illustration 23

The dual aim was pursued by ensuring that while each historical period was covered by an acknowledged expert, every major point discussed in the text was juxtaposed with relevant illustrations. In this way, 'Art in Wales' provides an essential visual reference book both as an end in itself and as a source for further specialised study. A second volume, covering the period from 1850 to the present day, will complete the ambitions of this particular project.

Of the six essays which make up the text of this volume, four are by the original contributors. A new article extending the range of the section on Early Christian art has been added by Donald Moore and another on Roman Art in Wales, written by Catherine Johns, has replaced the original catalogue article by George Boon of the National Museum of Wales.

Acknowledgements are due to George Boon for his valuable advice in the preparation of the new essay and its illustrations; to the staff of the National Museum of Wales for their generous help in the overall preparation of the book; to Arthur Williamson, who photographed the contents of the 1964 exhibition, many of whose photographs are reproduced in this volume; and to the numerous individuals and institutions who have kindly given permission for illustrations to be used of objects in their possession.

Eric Rowan

Detail of illustration 15

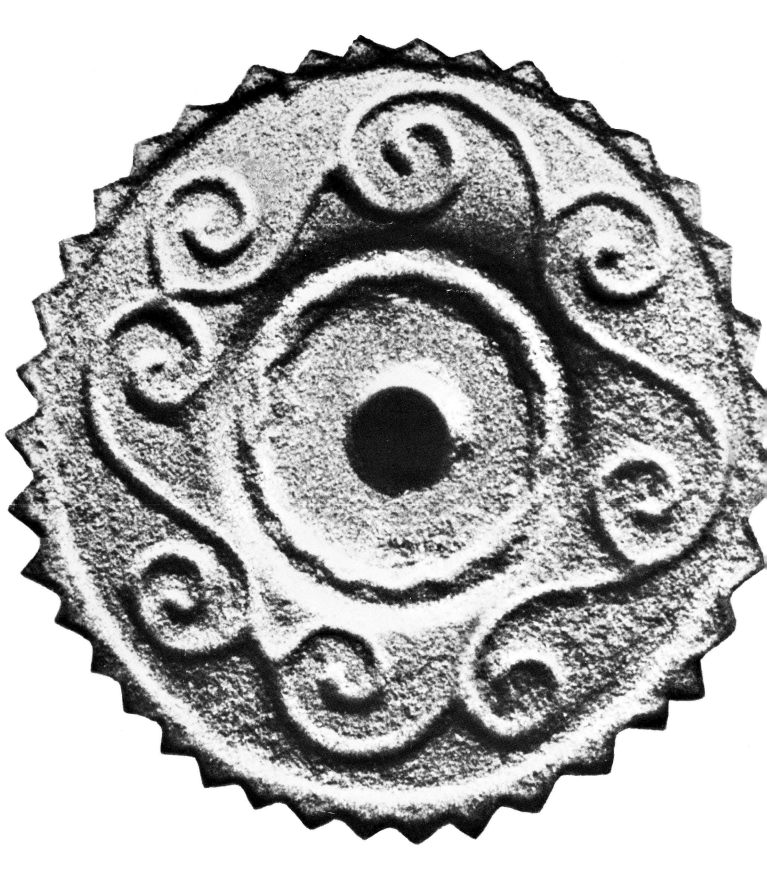

10

the evolution of art

The Oxford Dictionary definition of art is, a skill, especially a human skill as opposed to nature, or a skill applied to imitation or design. It follows that within a society the artist is distinguished by his ability, but it does not follow that he is therefore exceptional. In this survey we are concerned primarily with the plastic and visual arts, that is, with design and, later, interpretation. Design, in the sense of drawing patterns or symbols, and interpretation, in the sense of transforming visual facts into works of art, are basic activities of man. They form what has been described as his aesthetic impulse. Even today, when our reactions are so sophisticated and conditioned, this impulse survives in the doodle or the graffito. We may look for works of art therefore on two counts: as reflecting a skill and as reflecting an aesthetic impulse.

Because there is a constant development in man's ability it follows that these skills will also change and generally increase, with the result that what was once a work of art becomes eventually debased as it requires comparatively less skill to produce. Throughout this book only the new and most accomplished skills are represented, and hence folk art has been excluded.

From the earliest periods of history some flint and stone war-heads are shown. Such implements supplemented man's natural abilities and made him a more powerful animal. Probably nearly every man could make such a war-head, but some undoubtedly would have made them better than others, to last longer or to be sharper. Such men might eventually have been excused the rigours of the hunt when their special skill was recognised. They would then have become artists, living by their skill alone and justified within their society. Their skill was a vital part of the life of that community.

A decorated cup shows a later stage in the evolution of art. The cup was the essential need (the equivalent of the war-head) but it has been embellished and identified by its markings. This implies an interest on the part of its makers and users in a specific cup as apart from a type of utensil. Such a step, from the general to the particular, marks an increase in man's thinking ability and may be taken to reflect an increase in the organisation of his society. This is an example of the aesthetic impulse. The war-heads were made at a time when man's energies were devoted to survival (self defence, eating, sleeping, reproducing and

Detail of illustration 7

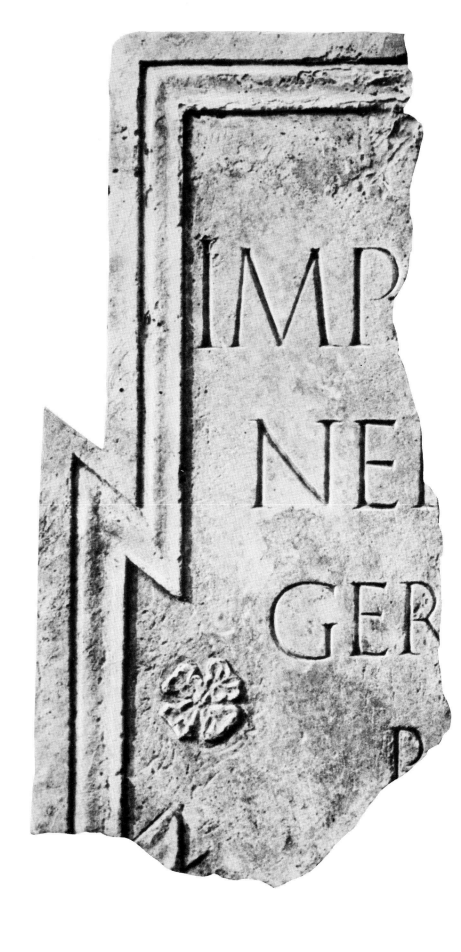

Detail of illustration 55

housing) while the bowl belongs to a lightly stratified society, when distinctions in precedence were beginning to be necessary.

In dealing with pre- or proto-historic periods, surviving works of art provide the greater part of evidence for the kinds of community which existed and their importance and interest today far exceeds, it may be supposed, their original status. In determining the history of art we are at the mercy of such chance survivals.

There is a considerable gap in time before we come to the Celts, who were a defined race with their own mythology and their own distinctive way of living. They were an agricultural or pastoral people, warlike and powerful. The works of art they produced, that have survived, reflect this culture and emphasise the status of the war lord. The most impressive are their ornamented shields, swords and sheaths, while on a more intimate level there are tankards, firedogs and bowls. Most are characterised by a similar form of decoration which shows how strong their uniform culture was. Celtic art is not entirely abstract and decorative, but on the other hand it is never imitative. When human or animal heads were used as motifs or subjects they were generally seen schematically and realism was not a yardstick of success for the craftsman. He was clearly inspired, on occasion, by what he observed, but this became the basis for a pattern and not the object of imitation.

The early Christian monuments grew out of the Celtic art forms. These monuments were again a functional form of art; none was carved for a mason to prove his skill. Few of them could ever have been conceived as a whole before work began; they evolved out of a stone, whose size was probably the most important single factor in their individual evolution. The salient characteristic is their decoration; it is geometrical, abstract and less imaginative than earlier Celtic work. This is perhaps the result of the intervening Roman invasion. The inscriptions are haphazard and the tentative portrayals of the human figure are similarly crude. Both the lettering and the human figure presented greater difficulties than the decoration, which belonged to an older and well-established tradition.

In the context of this survey these stones have two important features. Firstly, they are Christian monuments and this new religion was to influence all succeeding works of art. It directed man's attention to himself and engendered a humility which utterly denied the original vigour of Celtic art. This will be referred to again in this essay. The crude figures on these monuments may be considered as the beginnings of that emaciated and rigorous Christian art which characterises the middle ages.

Detail of illustration 60

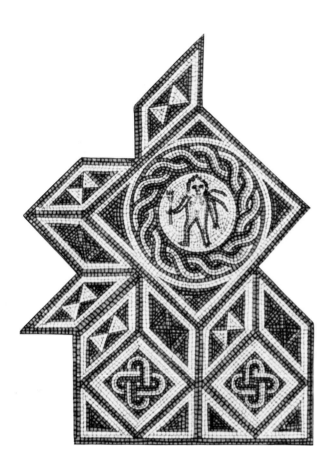

The second feature of these monuments is their impact. The mysterious power of the symbol has now been lost and, unless exceptionally, it is impossible to experience any apprehension before these mighty stones. It is possible, however, to admire them in much the same way as a large Henry Moore sculpture. This parallel is useful because it underlines the anomalies of our attitude to works of art today. The sensation which we now feel was once an integral part of a vital religious experience. At that time it was quite unknown to cultivate sensation for sensation's sake. We still ask of art the satisfaction of our surviving mystical feelings and we may find this satisfaction best catered for by those functional works of art from the distant past.

Those works of art which we have so far discussed may all be described as primitive, in the sense that the society that produced them was unurbanised and fearful. Perhaps the most important single factor for their appreciation is the understanding of the changing nature of reality, which is man's interpretation of his environment and experience. A work of art is the result of an interaction between imagination and reality. The primitive imagination was closely linked with environment and experience, in a way which is now quite alien to us. It had the task of reconciling the one with the other when both were sources of suspicion and fear.

There is a stylistic feature that all these primitive works have in common, the tendency to design as apart from imitation. For an imitative art to be prevalent man must be reconciled to his environment. He must be able to see things for what they are and not for what they might become; he must be fearless. Imitative art is an art of no immediate use or purpose. It emerges in a well organised society where there is leisure both to produce and to enjoy such art. None of the

Detail of illustration 53

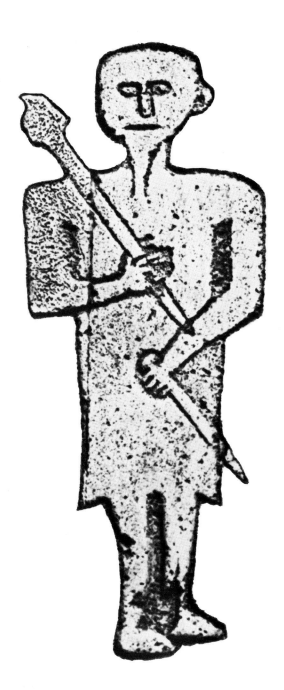

peoples we have met so far had such leisure and none was completely master of his environment.

The perfect Trajan lettering of the Roman inscription reflects a logic, pride and confidence utterly beyond the Celt living at the same time. Indeed, as lettering it has probably never been bettered. Compared with the crude inscription on an early Christian monument it provides a direct measure of the qualitative difference between north and south. The Romans had dominated most of the known world and their way of life and their art was to be a measure of achievement in Europe for centuries to come.

The Romans were very content to post only four major forts in Wales, two in the north at Caernarvon and Chester and two in the south at Caerleon and Carmarthen. Tacitus, their historian, described in his civilised Roman way the native Welsh tribes, the Silures in the south and the Ordovices in the north, as brave and resolute fighters. He remarked also on the swarthy appearance and curly hair of the Silures. Tacitus shows admiration for their tenacity and an objective curiosity for their devious other characteristics. Two different worlds were confronted and they were irreconcilable.

The fragments shown here are not the work of Rome itself, but of Roman settlers and they may therefore be classified as Roman provincial. Between the Trajan inscription, the jewellery, the Samian pottery and the ivory carvings there is a complete range of craftsmanship, from the coarse to the delicate. Within organised Roman society the artist-craftsman existed on many levels, ranging from the mystical to the entertaining, but in all he remains substantially a figurative artist controlled by his patron.

Details of illustration 88

15

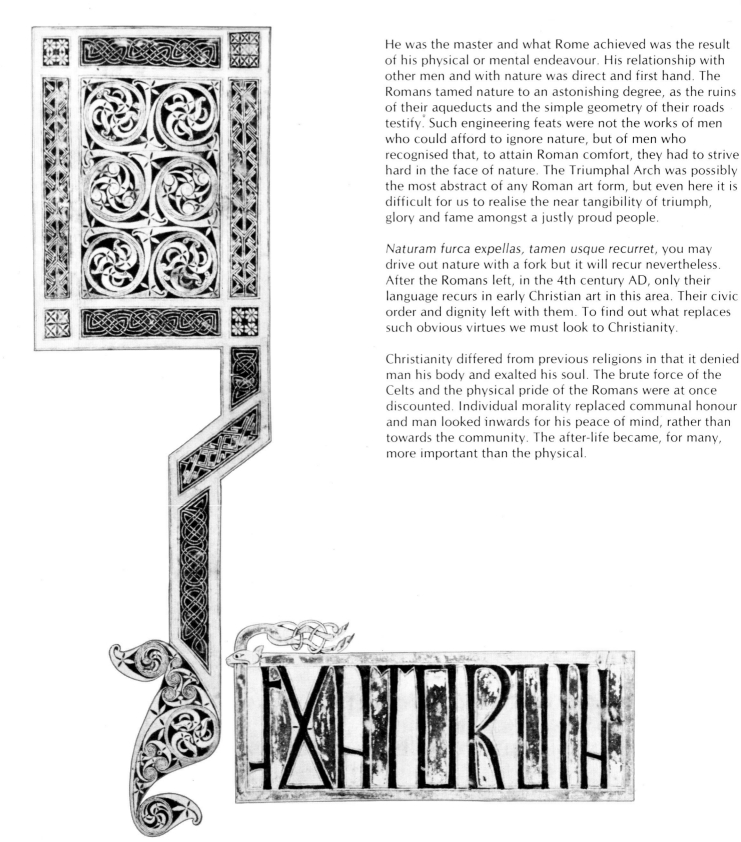

He was the master and what Rome achieved was the result of his physical or mental endeavour. His relationship with other men and with nature was direct and first hand. The Romans tamed nature to an astonishing degree, as the ruins of their aqueducts and the simple geometry of their roads testify. Such engineering feats were not the works of men who could afford to ignore nature, but of men who recognised that, to attain Roman comfort, they had to strive hard in the face of nature. The Triumphal Arch was possibly the most abstract of any Roman art form, but even here it is difficult for us to realise the near tangibility of triumph, glory and fame amongst a justly proud people.

Naturam furca expellas, tamen usque recurret, you may drive out nature with a fork but it will recur nevertheless. After the Romans left, in the 4th century AD, only their language recurs in early Christian art in this area. Their civic order and dignity left with them. To find out what replaces such obvious virtues we must look to Christianity.

Christianity differed from previous religions in that it denied man his body and exalted his soul. The brute force of the Celts and the physical pride of the Romans were at once discounted. Individual morality replaced communal honour and man looked inwards for his peace of mind, rather than towards the community. The after-life became, for many, more important than the physical.

Details of illustration 77

The effect of this cosmic re-thinking on the artist was virtually to castrate the earth-bound, virile tradition which he inherited from the past. We must not make the mistake, however, of placing the artist above his society. He shared the thoughts of his fellows and he applied his skill to interpreting the new religion, which dictated a whole iconography based on man. The principal characteristic of this new man was his humility; his submission to persecution, ridicule and resentment, knowing that he had a longer life to come. At the same time, since Christianity emphasised individual salvation, the strong corporate sense of the Celt and Roman was overthrown.

Easily the most impressive medieval works are the large wooden figures from tomb or reredos. They reflect clearly this evolution of the human form in Christian art. The stiff and formalist body of the thirteenth-century tomb becomes gradually transformed into the still suffering, but living, figure of Jesse in the fifteenth-century. Both figures are seen in relation to their religion, at the mercy of their God. The Christian craftsmen were working within the Christian idiom, with the ostensible purpose of glorifying God, but already Christianity's individualism must have encouraged their independence. For the first time in Europe artists were working in a society which believed in an individual salvation and eventually such an outlook was bound to value an individual, as apart from a typical, skill. In Italy this stage had been reached by the end of the thirteenth century, and respect for the artist increased from that time.

With the growth of the artist's skill, and the growing respect it was earning him in society, domestic or pleasurable art came into being. This is the most familiar form of art to us now. It is basically the result of the artist losing a fast harness of ideology and implies simply the birth of a humanist art, concerned with the illustration of human experience. It is the time when novels and stories, as apart from heroic sagas, appear in European literature, (and when Oliver Cromwell asked his portrait painter to paint him as he really was, *warts and all*).

The patronage of such art came from the affluent, and its character was initially a reflection of that nobility which ensured its continuance; but Wales possessed few gentry, and had no outstanding centre of trade or government where the artist could easily find employment. If we turn to the history of painting in England, where similarly there was little tradition of visual art, we find Holbein, van Dyck, Lely and Kneller were assured, as distinguished visitors, of constant employment as portrait painters in London, a centre of government, of trade, and, therefore, of wealth. They stimulated a national school of painters.

Some of the earliest portraits look like icons, closely related to the tradition of Christian art. But the inherent stiffness is gradually lost, and by the eighteenth century the other extreme is reached, each portrait having a rather mannered and uncomfortable pose. Portraits are, of course, a functional form of art and portrait painting became increasingly irksome to the painter as, with time, he came to wish for freedom to express his ability. By the eighteenth century most portraits were being produced along mechanical lines; the master painter would supply the head while drapery men would add the costume according to a specified pose.

The other main genre of humanist art was the landscape. It first arose as man's curiosity turned to his environment and eventually came to offer a mental retreat from the business of living. Some of the first British landscapes were little more than presentations of a peaceful Arcadia, based on the Italian Campagna bathed in a golden evening glow. From this fictional beginning the landscape of fact was born, and Richard Wilson's views of *Snowdon* and *the Valley of the Mawddach* are among the earliest examples of factual landscape in British art. Wilson developed through the Italianate convention.

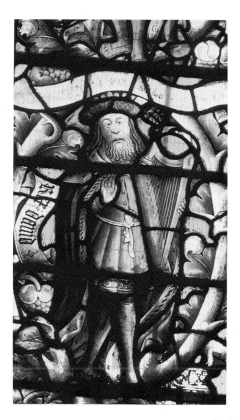

Detail of illustration 97

Detail of illustration 121

The water-colour painters, whose activity dates from the very end of the seventeenth century, had always been concerned with fact and the records they have left of British landscape are now invaluable. Francis Place, whose work is shown, was once arrested in Wales when he was seen drawing a castle and fortification. This suggests but one use for the factual and accurate observer.

Towards the end of the eighteenth century we find sensation introduced for sensation's sake. The romantic movement was the consequence of a conflict between body and mind, which had previously been set in strict hierarchy by the Church. No longer were men able to accept such a passive reserve; the growing revolution of industry was reducing many people to an animal level, and making many more dissatisfied with their experience. Artists like Turner stressed personal sensibility in their work, and thus aligned themselves subconsciously with the growing band of disconsolates. Turner clouded his landscapes with atmospheric effect, so that the substance dwindled beneath. It will be remembered that primitive man had been afraid of nature; the man of the romantic era revelled in it and saw in nature's undisciplined moments, in wild mountains, cataracts and storms, a relief for his own frustration. The wild landscape of Wales presented the perfect foil for such temperaments.

Detail of illustration 103

Art had been a fundamental activity when imagination was necessary and well exercised in daily life. The less functional the imagination, the less central became the art of that period, and the more decorative. Art had helped to allay fear, and the artist had been on a level with the priest. There were other purposes for art, however; it could help to preserve a social hierarchy with its reverence, it could record people and events and it could, and indeed still does, present an imaginative reflection on reality. But this last use is the most difficult to appreciate, and the most marginal of all. The appeal of Turner's tempestuous landscapes was by no means universal, while the stone war-head was a tool, not having to rely on any aesthetic appeal.

John Ingamells

Detail of illustration 130

19

PRE CELTIC AND CELTIC PERIOD

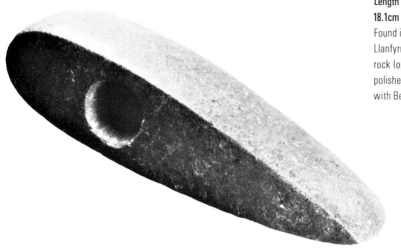

1 Stone Axe Hammer
c 1800-1600 BC
Length 7.125in
18.1cm
Found in 1927 in a round cairn at Pentregalar, Llanfyrnach (Dyfed). Made of an igneous rock (ophitic olivine gabbro), perfectly polished. A Copper Age type associated with Beaker pots in Britain.

Previous page
Detail of illustration 9

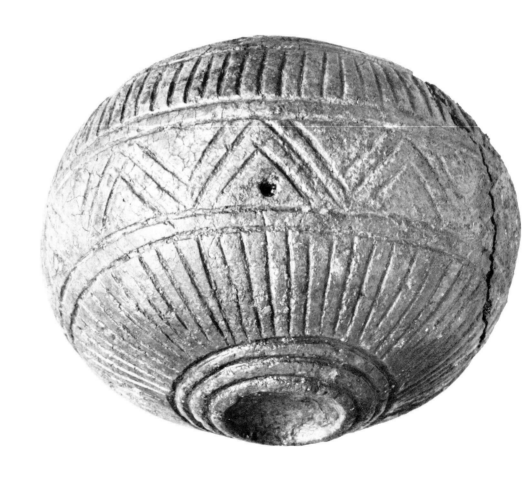

2 Pygmy Cup
c 1400-1200 BC
Height 2.625in
6.5cm
Found with cremated bones inside a large urn of Middle Bronze Age type in a secondary cist in a round barrow at Talbenny (Dyfed). The form is unusual and may be inspired by a vessel made of sheet metal: note the foot-ring.

Man's appreciation of aesthetic values goes back, without a doubt, as much as 30,000 years, to the advanced hunting communities of the European Upper Palaeolithic, some of whose paintings and carvings are clearly inspired by a sense of beauty, however large a part magic played in their use. This early art, however, as far as we yet know, had little reflection in the poor communities which lived as early as this in Wales, on the fringe of habitable Europe. The earliest human artefacts so far found in Wales which seem to show a concern for aesthetic values belong to the Neolithic and Early Bronze Age (c. 3000-1500 BC). They are weapons and tools made of flint or fine-grained igneous rocks which reward polishing. Some of these specimens not only show appreciation of fine material but a feeling for good design and craftsmanship which was the foundation for more ambitious work in later prehistoric times. At the beginning of the Metal Age, about 1800 BC, Beaker pottery, with its varied geometric patterns, introduced to Wales a peasant tradition of geometric ornament which was to last there in various forms until the arrival of the La Tène Celts in the 4th or 3rd century BC. Sometimes the form of pottery is influenced by vessels of gold and other metals but the geometric patterns appear also on metal ornaments like the gold lunula from Dolbenmaen and the Caergwrle bowl. On the latter, what is probably a representation of a boat with oars and *magic* eyes on the bows is rendered in the same rigidly geometric convention. Only the contacts which Continental Celts had with the Classical civilisation of Mediterranean lands, from the 6th century BC onwards, finally broke this dependence on geometric patterns, but in Britain even this indirect inspiration from plant and animal forms was rapidly modified under the influence of pre-historic tradition with abstract and geometric forms.

3 Gold Lunula
c 1600-1400 BC
Diameter 9in
22.8cm
Found c 1870 in a bog at Dolbenmaen (Gwynedd). (The only known example from Wales). Such lunulae, from the Early Bronze Age, were apparently made by Irish craftsmen and most have been found in Ireland, while the remaining finds are scattered over north-west Europe; their geometric ornament is engraved or punched. They belong to a widely distributed class of collar, perhaps sometimes an emblem of social status, which was variously constructed of multiple necklaces, stone plaques or sheet metal during the 3rd millennium BC and later in the Mediterranean lands and western Europe. The outstanding example is the collar worn by Egyptian nobles.

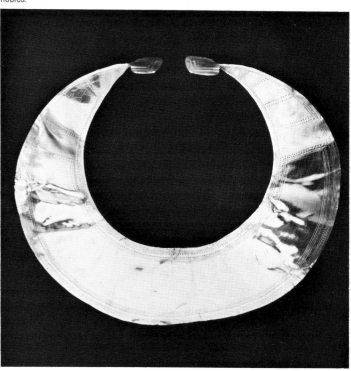

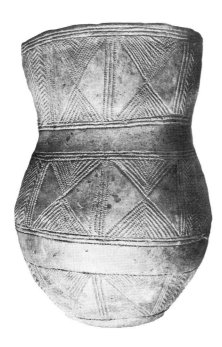

4 Long-necked *Beaker*
c 1800-1600 BC
Height 7.875in
20cm
Found in 1929 in a burial cist, covered by a round barrow, at Llanharry (Glamorgan). Hand-made pottery, decorated with notched lines forming panelled geometric patterns.

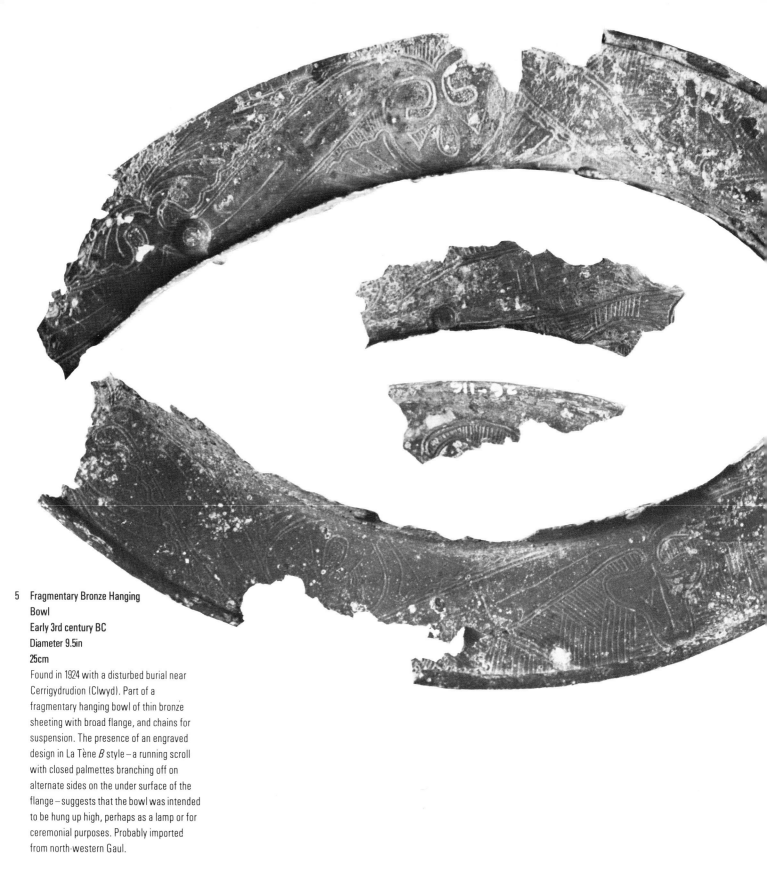

5 Fragmentary Bronze Hanging
 Bowl
 Early 3rd century BC
 Diameter 9.5in
 25cm

Found in 1924 with a disturbed burial near
Cerrigydrudion (Clwyd). Part of a
fragmentary hanging bowl of thin bronze
sheeting with broad flange, and chains for
suspension. The presence of an engraved
design in La Tène *B* style – a running scroll
with closed palmettes branching off on
alternate sides on the under surface of the
flange – suggests that the bowl was intended
to be hung up high, perhaps as a lamp or for
ceremonial purposes. Probably imported
from north-western Gaul.

Celtic art in prehistoric Wales

For over a thousand years there existed in the British Isles a distinctive artistic tradition which can be identified as Celtic. It makes its first appearance in these islands as part of the equipment of invaders who can be traced back archaeologically to parts of the Continent which are known to have been Celtic then, and its later stages are best represented in those parts of the islands which were least affected by the Romans or by later Germanic settlers. On the Continent the artistic tradition which we recognise in the British Isles as Celtic is equally well defined. It developed within the sphere of a great empire of archaeological material, quite sharply bounded in time and space, which has been named after a type-site, La Tène, on the Lake of Neuchatel in Switzerland, where a great deposit of religious offerings was found a century ago. This archaeological empire corresponds almost exactly with the historical empire occupied by the Celts between the 5th and 1st centuries BC, which started from a Hallstatt nucleus shaped in the 7th and 6th centuries BC, in the Upper Rhine and Danube basins and in eastern France, and later expanded into what are now Spain, the British Isles, northern Italy, Hungary, the Balkans and even Asia Minor. This empire was military and cultural, rather than political: indeed, if it had been fully integrated politically it might have overwhelmed the classical world of the Mediterranean instead of playing a Viking role. At first it was ruled by princes whose power and wealth attracted Greek and Etruscan merchants, whose offerings of magnificent bronze vessels and painted pottery are found in their great chambered burial mounds. Later, in the 4th and 3rd century BC, a larger military class emerged, whose moderately equipped graves, without mounds, are found in large cemeteries. These are the people who threatened Rome and Delphi in the 4th and 3rd centuries BC, and for long struggled to maintain a frontier against the Germans in the north and other non-Celtic tribes in the east, but were, by the 2nd century BC, rapidly giving way, outside of Gaul and the British Isles, before the advancing Romans and Germans.

6 Wooden Bowl
c 1000-800 BC
Length 7.25in
18.4cm
Found c 1820 in a bog (formerly a sacred pool?) near Caergwrle Castle (Clwyd). Boat-shaped bowl of oak decorated at the rim, with gold leaf on which are finely engraved concentric circles suggesting a row of shields hung from the gunwale and, lower down, with an excised pattern possibly representing oars and waves and inlaid with gold leaf wrapped round a soft material. There are *eyes* at the bows, similarly inlaid, and the whole may be inspired by the sort of Tartessian (south-west Iberian) merchant vessel, which is now believed to have navigated the Atlantic coasts of Europe, in collaboration with the Phoenicians, during the Late Bronze Age.

7 Metalworker's Mould
c 300-200 BC
Width 4.66in
12cm

One of the valves of a master-mould, made of local Old Red Sandstone, found on Worms Head (Gower), some time before 1920. It shows no sign of ever having had molten bronze poured into it, and was probably used for making wax models from which expendable clay moulds would have been made. The objects to be produced were ornaments – a large ring and three ring-beads, two of them with attached spherical protuberances. The latter are a continental early La Tène type and the 'wave tendril' ornament on the large ring embodies a simple motif of classical Greek art which was the starting point of many continental La Tène *B* scroll patterns, seen on brooches, neckrings and bracelets. The mould therefore seems to represent an immigrant metalworker.

It was growing contact with the Mediterranean world, first by the late Hallstatt princes and through the medium of trade with Etruscans and Massaliot Greeks, and then by war and conquest beyond the Alps, which led a gifted barbaric people with a long tradition of skilled craftsmanship to abandon its prehistoric, purely geometric art and develop a quite distinctive style applied above all to metalwork, but also to stone and pottery and, no doubt, to woodwork and textiles which are lost to us. That style is marked above all by curvilinear patterns, inspired by the floral motifs of *classical* art, but which finds a place in those patterns for animals and even for man. That place, however, is entirely different from what we find in the classical world because we are, after all, dealing with *barbarians* whose attitude to political, social and religious life is quite different to that of the fully urbanised Mediterranean world. The rural Celt did not wish to shape complete and credible, if somewhat idealised, forms, from the nature he found around him—as the Greek or Roman did, to the greater glory of the city and its magistrates, or the gods of a conventional Pantheon no longer, at bottom, taken very seriously. He was attracted, however, by the fantastic creatures of oriental art which came to him through looted Persian metalwork or imported objects of the orientalising phases of Early Greek or Etruscan art. He himself had long been accustomed to decorate metal vessels with schematized birds which were probably thought to have a protective value, and the more varied creatures which form the plastic decorations of early La Tène vessels and personal ornaments are no doubt similarly intended to influence the local unseen powers with which the primitive Celtic mind peopled the world of nature. Because of this mystic content, there was an increasing tendency to substitute a part—usually the head—of beast or man for the whole.

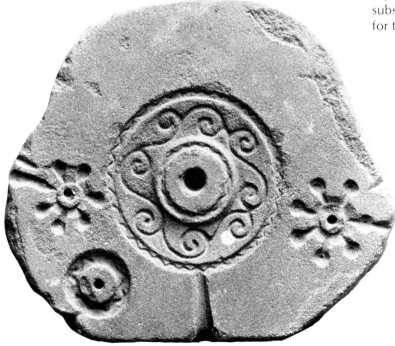

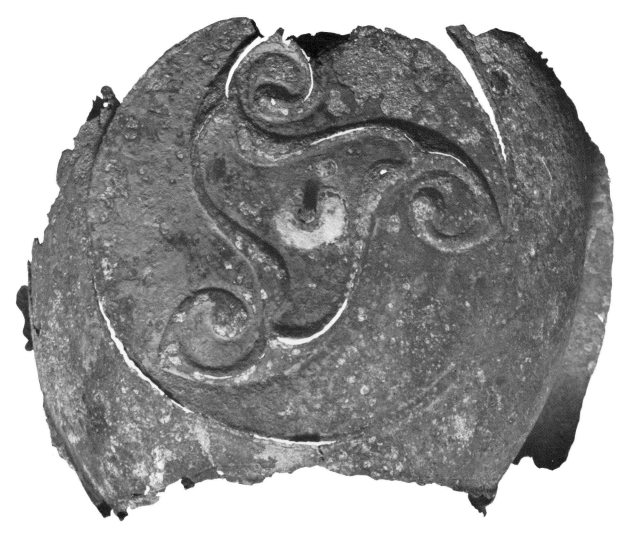

Fragmentary Bronze Shield Boss
c 200-100 BC
Width 5.125in
13cm

Found in 1963 with other fragmentary objects of copper alloy in a metalworker's deposit which had probably been previously disturbed, on the mountainside north of Tal-y-llyn (Cader Idris, Gwynedd). The domed bronze sheeting formed part of the ornamental cover of a spindle-shaped wooden boss, placed longitudinally on an oblong wooden shield of the Celtic Iron Age type in use on the Continent in La Tène times. The sheeting probably extended originally to cover the whole of the wooden boss, but the extensions have been broken off, leaving only the central area with its circular decorative roundel, on which a triskele motif is embossed. Like the general form of the shield-boss casing, the triskele relates to early La Tène tradition on the continent, while the hatched triangles, done with a rolled graver outside the roundel, hark back to continental Hallstatt art. On the other hand the use of the rolled graver to outline the areas embossed, as on other fragments from Tal-y-llyn, relates to continental 'Middle La Tène' practice of the 3rd and 2nd centuries BC anf the peaked volute ('trumpet pattern') terminals of the triskele are a feature of the distinctive British La Tène style.

9 Engraved Plaque from Shield
c 200-100 BC
Diameter of roundel 3.33in
8.5cm

From the Tal-y-llyn deposit. The engraved roundel contains a triskele exactly like the one on the shield-boss, reserved against a matted background in which the rolled graver has been used to fill in the basket-work pattern like those similarly engraved on tubular neck-rings of the 5th century BC from eastern France. The plaque is *pelta*-shaped, one of a pair which in all probability flanked the shield-boss, thus constituting three triskeles, which no doubt had a superstitious value on the shield.

Early Celtic art, as we know it on the Continent, as well as in Britain, must be interpreted in relation to its function. It is governed by the objects which it decorates and the needs of its patrons. The latter were, in the first place, a military aristocracy whose status symbols were chariots, horse-harness and weapons, and whose wives wished to impress their neighbours with fine cauldrons, milk-pails and personal ornaments. Craftsmen were part of the entourage of this military aristocracy and their art was incidental to the production of the desired equipment: its function was partly ornamental and partly protective, in so far as traditional ingredients (such as the human masks which are common on the Continent and even appear in Wales in the newly-discovered Tal-y-llyn hoard, or the *triskele* designs which were so popular in Britain), may have been thought to have magic properties. It so happens that this material is

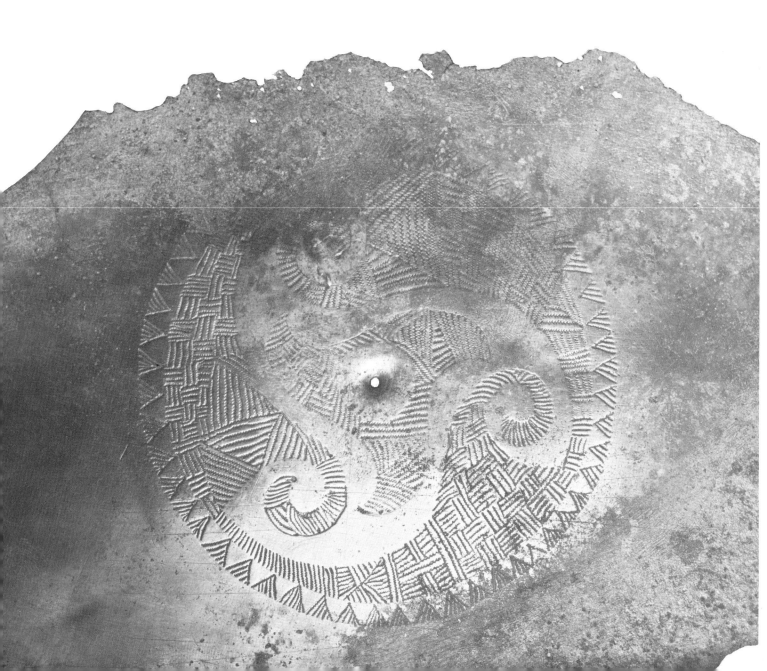

prominent in the archaeological record, because on the Continent most of our evidence comes from burials, while in Britain rather more of it comes from hoards deposited by the warriors or their craftsmen. But we must not forget that there were other patrons in the old Celtic world, who could have given more scope to plastic and representational, as opposed to purely decorative art—priests. Unfortunately nearly all the images which were undoubtedly carved for these priests and their shrines are lost to us, because wood was the material normally used. Only on the southern fringe of the old Celtic world, on the Mediterranean sea-board of France and to some extent in the Rhineland was stone extensively carved for shrines or tombs, and the human form portrayed under Greek influence, but elsewhere, even in Wales, heads are not unknown. These are most important for our appreciation of later Celtic Christian art.

10 Fragmentary Brass Shield-Boss
c 200-100 BC
Length 5.1in
13cm

From the Tal-y-llyn (Gwynedd) deposit. Fragments from a second shield-boss which is too fragmentary for complete reconstruction. Metallurgical analysis of the main part has shown it to have been made of copper-zinc alloy, although a repair strip proves to be of normal bronze. The lay-out appears to have been very similar to the other shield-boss from Tal-y-llyn (8), but the decorative roundel encloses what appears to be a *palmette*-derived pattern related to continental early La Tène treatments of the classical motif, outline with the roller graver.

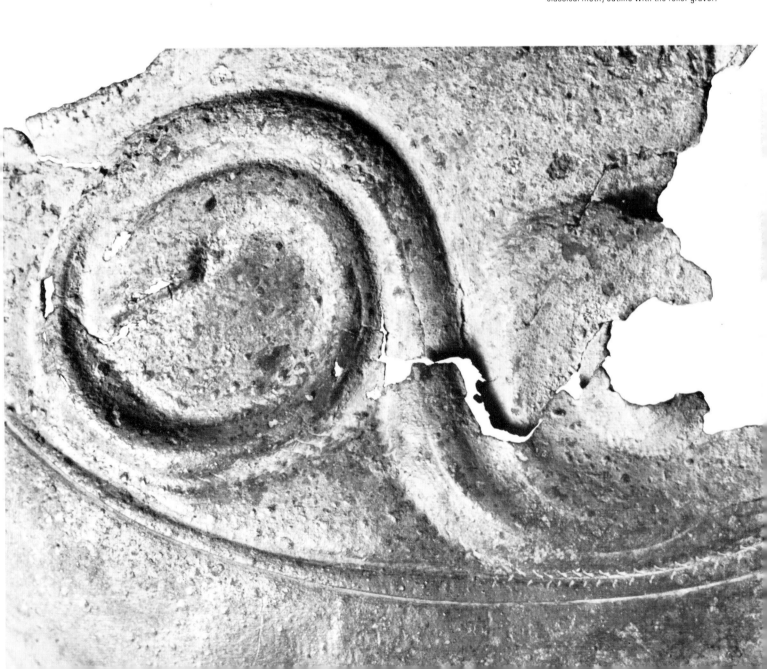

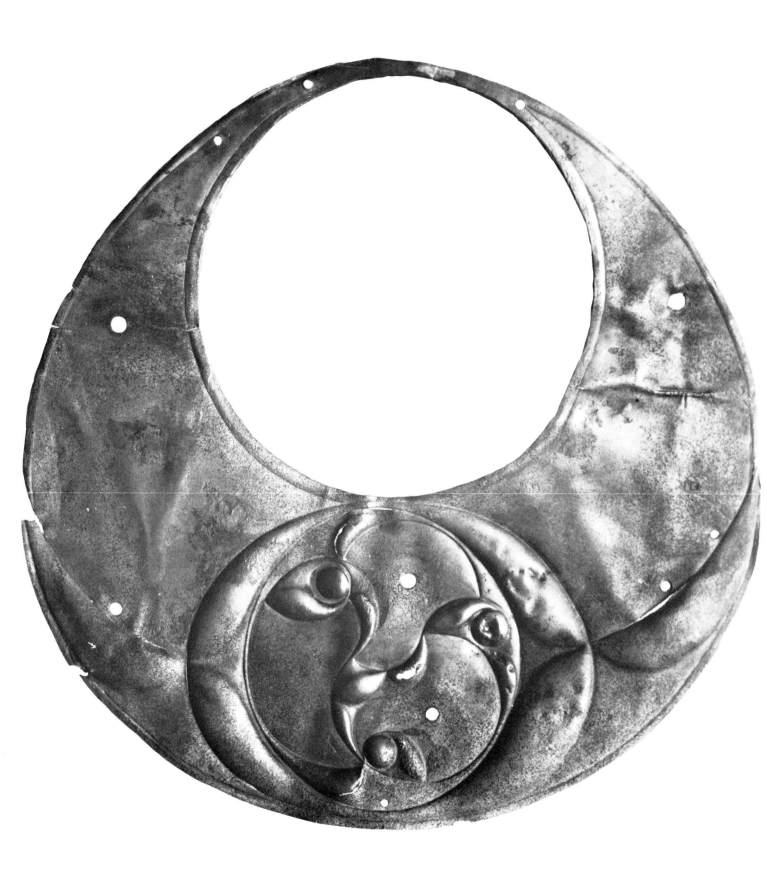

In the British Isles, we can have no doubt of the essentially La Tène character of the ornament which appears on warriors' equipment—sword and dagger, scabbards, ornamental sheet-metal from shields, chariot-fittings, harness and war-trumpets—or on neck-rings, bracelets, brooches and bronze vessels of various kinds. The *palmette* scrolls and triskele patterns which continually appear are directly derived from those which characterize the second or La Tène *B* phase of Continental Celtic art which followed the Celtic invasion of Italy in the 4th century BC. The zoomorphic element in the art, which is so strong in the earliest Continental phase, is represented in the British Isles mainly by much less naturalistic bird-and-beast heads incorporated in curvilinear patterns, and the immediate background here seems to lie in the Continental *Sword Style* of the 3rd century BC. It is on this century that the Continental contacts of the earliest Celtic art in Britain seems to centre, probably because of an actual immigration of Celtic warriors and their attendant craftsmen, whose technical influence can be seen in the use on the earliest British works of such *gimmicks* as the use of *tremolo lines,* made with a rolled graver, to outline elements in embossed patterns or to fill in background—a technique beloved by the late Hallstatt and early La Tène metalworker in the Upper Rhine and Danube basins. Undoubtedly, however, the reduction of the classical and naturalistic element which we see in the insular art, and the change in the objects chosen for decoration, reflect the adaptation of this new warrior aristocracy to a local environment in which pre-Celtic elements in the population and culture were still strong: this applies particularly to Ireland, where Celtic art seems to have languished for centuries after a brilliant beginning, only to come to full flower after fresh stimulus from the dying classical world, in the 5th and 6th centuries AD.

It has generally been maintained in recent years by such authorities as E T Leeds, S Piggott and C F Fox, that the first British schools of La Tène art developed on the eastern seaboard of England, afterwards spreading through southern Scotland to northern Ireland, although it has always been admitted that there was an important creative centre in the West Country. This view, however, was linked with an exaggerated theory of cultural retardation in the southern part of the *Highland Zone* which can no longer be maintained as far as the Early Iron Age is concerned. The eastern parts of Wales and the Marches contain one of the two largest concentrations of fortified prehistoric settlements in Britain and these have now been shown to have had a large population from the Late Bronze Age onwards, owing as much to continental influences and even immigration, as most other parts of southern Britain, while the western parts, though necessarily supporting a relatively small pastoral

11 Bronze Plaque
c 150-50 BC
Diameter 7.25in
18.4cm

Found in a ritual deposit at Llyn Cerrig Bach (Gwynedd) in 1943. Circular plaque with large eccentric opening and embossed decoration of 'leaves' and 'trumpets' centring on a roundel with triskele pattern rather different from numbers 8 and 9, and related more to the continental *boss* style of the 3rd and 2nd centuries BC as well as to later British La Tène trdition. The plaque had been riveted to a large flat surface, possibly a shield, and embellished with four ornamental studs, now missing, which may have been enamelled.

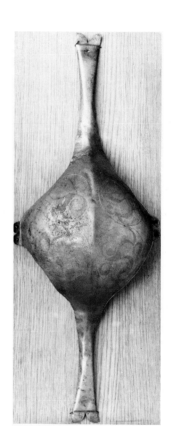

12 Bronze Shield Boss
c 150-50 BC
Length 14.375in
36.5cm

Found in a ritual deposit at Llyn Cerrig Bach (Gwynedd) in 1943. Ornamental casing for a spindle-shaped wooden shield boss of British La Tène type. The specialized form, with arcaded sides, is otherwise known only on the bronze shield-boss casing from Moel Hiraddug hil-fort (Clwyd) and a plain iron boss from the Isle of Wight. The engraved decoration consists of four roundels with triskele whirligig motifs like those on the embossed plaque, filled in with rolled graver matting. This pattern has been regarded as the starting point for the increasingly complicated engraved pattern found on the backs of bronze Celtic mirrors of the immediate pre-Roman period in lowland Britain, although the use of the rolled graver rarely occurs on the latter.

population had, as an economic compensation, local resources of copper and gold which were probably exploited by local craftsmen. It is in the light of these resources that the unique bivalve mould from Worms Head (Gower) should be seen, for this is made of local sandstone but seems to have been intended for the manufacture of wax models for the production of bronze ornaments of continental early La Tène type. The outstanding early Celtic metalwork found at various times in North Wales, at Llyn Cerrig Bach, Tal-y-llyn, Moel Hiraddug and Trawsfynydd can no longer be treated in every case as being imported or in transit between lowland Britain and northern Ireland. Indeed, it is now generally recognised that much of the ornamental metalwork of La Tène tradition which has been found in Ireland has peculiarities which suggest local production, although conditions here were in various respects like those prevailing in North Wales during the Early Iron Age. Moreover, it now seems that there are special links between some of the objects found on opposite sides of the Irish Channel and contacts between groups of craftsmen working in the two areas may be suspected. At the same time there are, in both areas, a very limited number of objects—the Cerrigydrudion bowl is a striking example from North Wales—which are sufficiently close in detail to continental specimens to be regarded as imports from across the English Channel and may therefore represent those trading contacts with Armorica and possibly even limited folk movements thence which led to the formation of the *Iron Age B* cultural group of recent British archaeological literature. After this initial

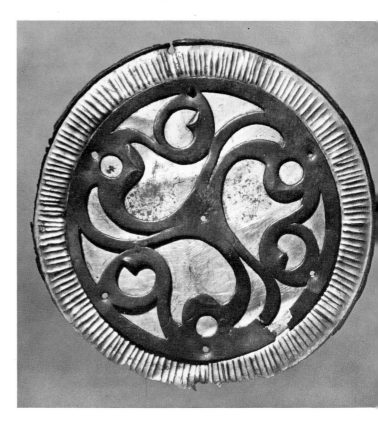

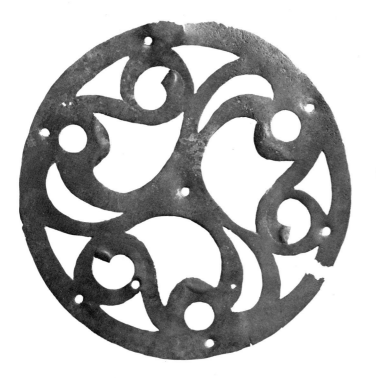

14 Brass Openwork Plaque
c 100-1 BC
Diameter 5in
13cm

One of the upper discs from the composite plaques found at Tal-y-llyn (Gwynedd), made of copper-zinc alloy. The decorative effect depends not only on the whirligig design, reserved against a tin-plated background, but on embossed 'leaf' motifs and rolled-graver lines related to the openwork pattern.

Composite Plaque
c 100-1 BC
Diameter 6.5in
16.4cm

The best preserved of four similar plaques from the Tal-y-llyn (Gwynedd) deposit. It consists of a lower, solid disc of tin-plated bronze and an upper, openwork disc of copper-zinc alloy. The two discs were riveted together against a wooden or leather background – perhaps a chest for the storing of valuable possessions. The openwork would allow a three-limbed whirligig pattern like numbers 11 and 12 to stand out like gold against a silvery background; the discs had however been remounted in a different relationship on at least one occasion.

phase of continental influence a western British tradition of Celtic art would have developed among indigenous craftsmen. La Tène ornament was applied by them to such things as shield-bosses and mirror-backs, which were not decorated on the Continent, and chariots, with their accompanying ornamental metalwork, survived in use long after their disappearance from the Continent, particularly in those regions of Wales, Scotland and Ireland which long resisted the Romans or were never conquered by them.

The western school of British La Tène art was still flourishing when the Romans arrived in Britain, and the clear evidence for the existence of good metalworking craftsmen in Wales in the conquest period helps to confirm the possibility of their having had local predecessors as far back as the 2nd century BC. The ornamental bronze collar from Llandysul, and the ritual 'spoons' like those from Penbryn belong to this period, as do the examples of red-enamelled horse-harness from the Lesser Garth and Seven Sisters hoards, which represent a local adaptation of 'Belgic,' south-eastern British forms with a stiff and symmetrical art style. The handle of the Trawsfynydd tankard is a superb example of early Celtic design in which the triskele motif lives on, as in other pieces from Scotland and Ireland, to provide some of the foundations for the Irish Early Christian metalworkers' repertoire. The wrought-iron fire-dog from Capel Garmon similarly shows a local blacksmith's adaptation of an idea derived from south-eastern Britain in the period just before the Roman conquest.

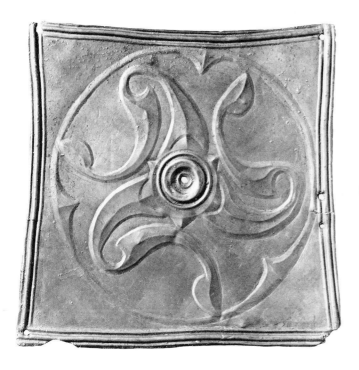

15 Copy of a (?) Bronze Plaque
c 100-1 BC
Diameter 6in
15.2cm

The original, now lost, was found in 1872 under debris at the foot of the innermost rampart at Moel Hiraddug hill-fort, Dyserth (Clwyd), together with the bronze casing of a shield-boss and peltashapqd plaques (like number 9, but plain). The metal of these pieces has not been analysed but it appears to be a copper alloy; the plaque here illustrated showed traces of tin-plating. The style of the triskele in this case is angular and appears to have been embossed on a wooden form, producing an effect like wood-carving; the double 'trumpet' motifs incorporated in the circular frame of the roundel recall the later 'Irish' style, the beginnings of which are seen in a number of British La Tène objects of the period immediately preceding the Roman conquest.

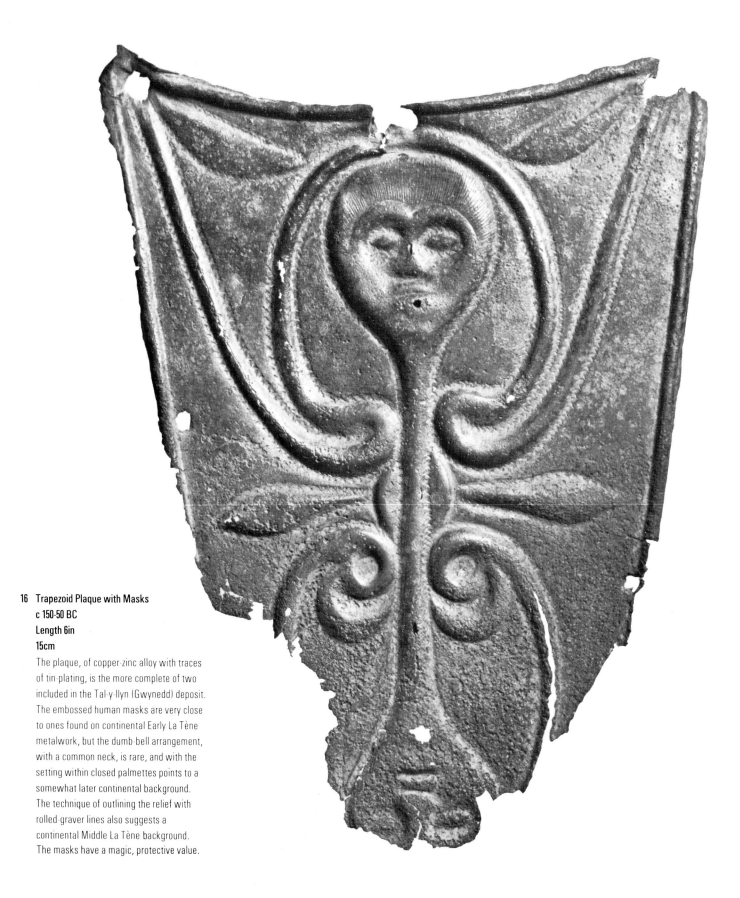

16 Trapezoid Plaque with Masks
c 150-50 BC
Length 6in
15cm

The plaque, of copper-zinc alloy with traces
of tin-plating, is the more complete of two
included in the Tal-y-llyn (Gwynedd) deposit.
The embossed human masks are very close
to ones found on continental Early La Tène
metalwork, but the dumb-bell arrangement,
with a common neck, is rare, and with the
setting within closed palmettes points to a
somewhat later continental background.
The technique of outlining the relief with
rolled-graver lines also suggests a
continental Middle La Tène background.
The masks have a magic, protective value.

Human Mask of Stone
c 150 BC - 50 AD
Diameter 6.6in
17cm

The mask is carved on a large water-rolled pebble, of local origin, which was recovered about 1970 from the bed of the river Twymyn at Bont Dolgadfan, Llanbrynmair (Powys). The features are water-worn and had probably been carried down-stream from the site of a pagan shrine, most probably of prehistoric Iron Age date. From its size and shape, it had probably been set in a recess in a wooden pillar, as was done both with actual human skulls and stone masks on stone pillars in Celtic shrines in Provence and Languedoc before these areas were conquered by the Romans. The cult of the severed human head was widespread among the ancient Celts, but was refined by contact with Greek colonies on the Mediterranean coast.

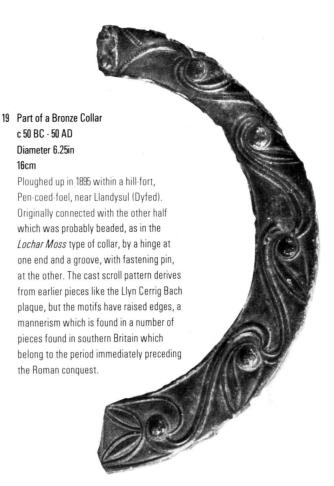

19 **Part of a Bronze Collar**
c 50 BC - 50 AD
Diameter 6.25in
16cm

Ploughed up in 1895 within a hill-fort, Pen-coed-foel, near Llandysul (Dyfed). Originally connected with the other half which was probably beaded, as in the *Lochar Moss* type of collar, by a hinge at one end and a groove, with fastening pin, at the other. The cast scroll pattern derives from earlier pieces like the Llyn Cerrig Bach plaque, but the motifs have raised edges, a mannerism which is found in a number of pieces found in southern Britain which belong to the period immediately preceding the Roman conquest.

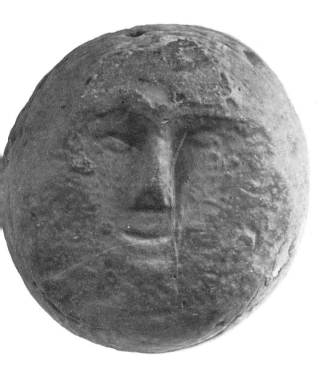

18 **Wooden and Bronze Tankard**
c 100-1 BC
Height 5.5in
14cm

Found, before 1850, in a bog near Trawsfynydd (Gwynedd). Tankard built of yew-wood staves encased in thin bronze sheeting, with a yew-wood base and a cast open-work bronze handle incorporating a scroll and four triskeles with central bosses. The cast bronze handles from a number of such tankards are known from southern Britain but none are as fine as this North Wales example.

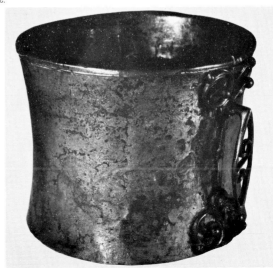

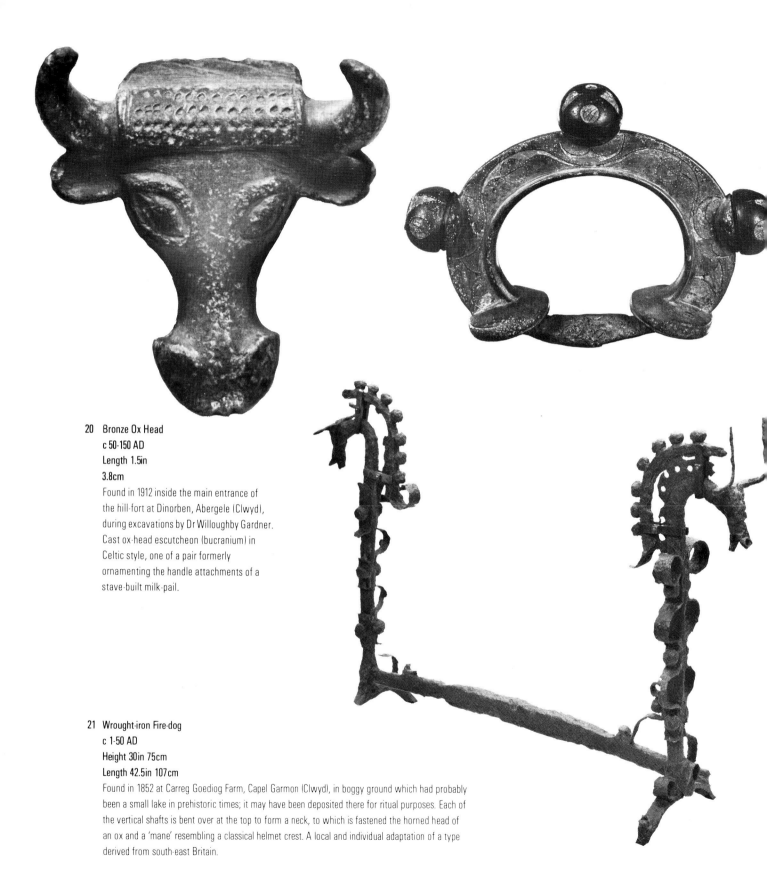

20 Bronze Ox Head
 c 50-150 AD
 Length 1.5in
 3.8cm
 Found in 1912 inside the main entrance of
 the hill-fort at Dinorben, Abergele (Clwyd),
 during excavations by Dr Willoughby Gardner.
 Cast ox-head escutcheon (bucranium) in
 Celtic style, one of a pair formerly
 ornamenting the handle attachments of a
 stave-built milk-pail.

21 Wrought-iron Fire-dog
 c 1-50 AD
 Height 30in 75cm
 Length 42.5in 107cm
 Found in 1852 at Carreg Goediog Farm, Capel Garmon (Clwyd), in boggy ground which had probably
 been a small lake in prehistoric times; it may have been deposited there for ritual purposes. Each of
 the vertical shafts is bent over at the top to form a neck, to which is fastened the horned head of
 an ox and a 'mane' resembling a classical helmet crest. A local and individual adaptation of a type
 derived from south-east Britain.

Enamelled Bronze Terret
c 1-50 AD
Width 5.5in
14cm

Found in 1965 with ironwork of late La Tène types, at the Lesser Garth quarry, Pentyrch (Glamorgan). The terret (or rein guide) is of the largest size and was probably mounted on the central pole of a war-chariot, while smaller terets were mounted on the yoke by which the two draught ponies were controlled. The broad flange and three partially detachable bosses are inlaid with opaque red glass, forming formal, balanced patterns of the style associated with the Belgic Celts in the period immediately preceding the Roman conquest. Terrets with flanges and bosses (also found in the Seven Sisters Hoard) appear however to be a local South Wales type.

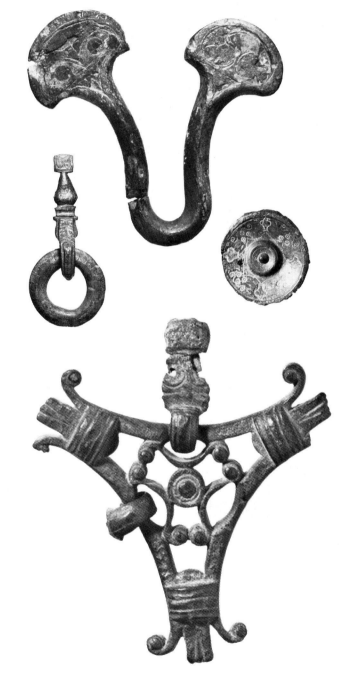

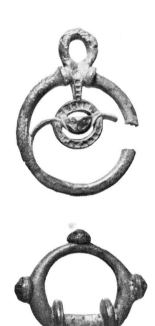

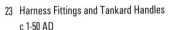

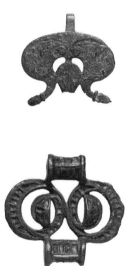

23 **Harness Fittings and Tankard Handles**
 c 1-50 AD

 Part of a metalworker's hoard found about 1875 in the bed of a stream near Nant-y-cafn, Seven Sisters (Glamorgan). The harness includes terrets (rein guides, as 22, but of smaller size) and rings from bridle-bits which were formerly decorated with inlaid patterns of opaque glass of more than one colour, as well as trace-hooks similarly inlaid in red. Some of the pieces are Roman in character, and possibly derived from an auxiliary cavalry unit.

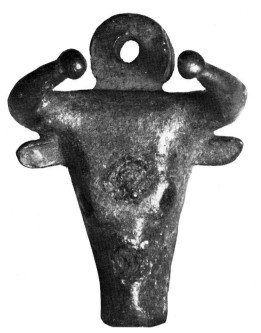

25 Bronze Cow Head
c 200-300 AD
Length 2.5in
6.4cm
Found in 1956 during excavations in the area of a large circular house of native Celtic tradition at Dinorben hill-fort, Abergele (Clwyd). Hardly any trace of La Tène style remains in this late piece, but the continuity of Celtic traditions of husbandry is represented by the balls on the tips of the horns which would have been fitted to cows (not bulls) to prevent them from damaging each other.

24 Bronze Cow Head
c 50-150 AD
Length 2.8in
7cm
Found in 1959 in a burial or cenotaph of a Romanised Celtic nobleman at Welshpool (Powys). Cast cow head escutcheon (bucranium), for a milk-pail, with eyes and muzzle treated in a La Tène manner, but with Roman provincial influences.

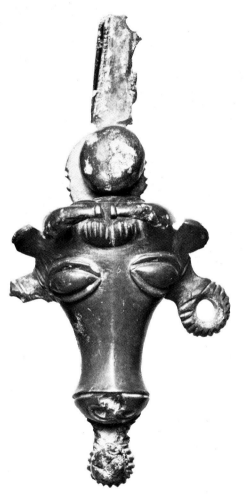

26 Base-plate for a Bronze Saucepan
c 200-300 AD
Diameter 4.5in
11.3cm
The base-plate was made to protect the solid base of an ordinary Roman saucepan of a type made in Campania in the 1st century AD, when that base had become worn. The base-plate itself was worn when the saucepan was deposited, together with late Roman coins, in a cave at Kyngadle (=Coygan) near Laugharne (Dyfed). This openwork base-plate has a solid but crudely made triskele, indicating the survival of traditional Celtic motifs among local metal-workers in South Wales long after the Roman conquest.

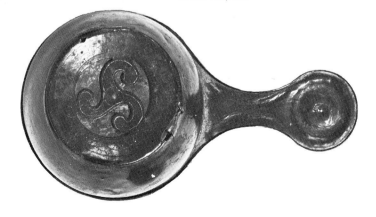

With the completion of the conquest the native tradition of craftsmanship was by no means extinguished locally. Naturally, the military application of La Tène art declined, but there were still patrons in Wales and Scotland for native makers of bronze vessels like the saucepan, with open-work false bottom incorporating a triskele, found with 3rd century Roman coins near Laugharne, Carmarthenshire, or the bronze ox-head *escutcheons (bucrania)* which were made for the handle attachments of wooden milk-pails in the 2nd and 3rd centuries AD at Dinorben and elsewhere. It is true that Wales during the Roman period, however slowly, came to be penetrated by cheap, mass-produced pottery and metalwork of provincial Roman character, produced for the markets of the lowland towns, on which no Celtic ornament survived. But economic integration came slowly, not so much because of periodical military resistance as because of the lack in this mainly pastoral region of an agricultural surplus of the sort that interested the Roman army, at least in the early days of the province, in addition to the mineral resources which it had promptly appropriated. Having little with which to go shopping for exotic goods in the market places at Wroxeter, Kenchester, Caerwent or Carmarthen, the upland stock-raisers of Wales still needed the local craftsmen, and so it came about that the local La Téne tradition lived on in Wales and the Marches not only in

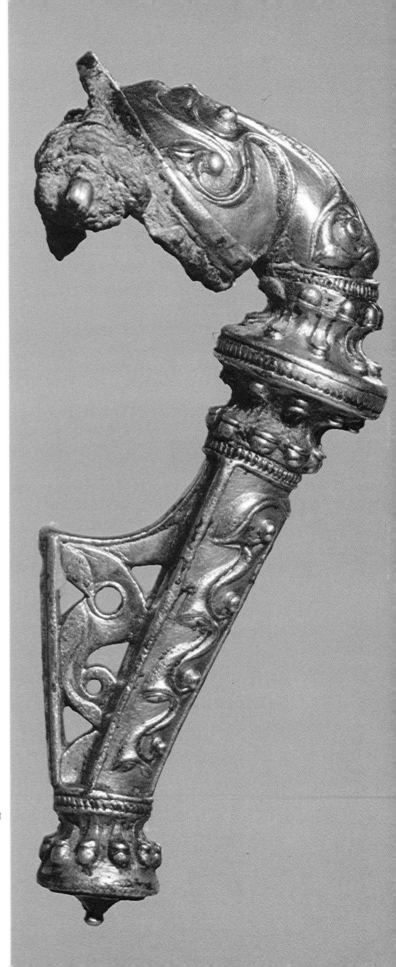

Reconstruction of silver, parcel-gilt
Trumpet Brooch
c 25-50 AD
Length 2.5in
6.2cm

The original (in Carmarthen Museum) was found, before 1968, in fragments in a workman's trench trench in Priory Street, Carmarthen, near the line of the main east-west street of the Roman town of Moridunum. It represents the finest, and probably the earliest known example of the Romano-British 'trumpet' brooch, the development of which extended into the 2nd century AD. Many of these brooches have decorative details derived from British La Tène tradition, but the Carmarthen brooch bears a trumpet scroll pattern, in cast relief, which stands close in style and quality of execution to the best western British La Tène pieces of immediately pre-Roman date. The fact that later, less sumptuous examples of this form are common in Wales and the Marches may mean that the Carmarthen brooch was made in Wales and that the gold used to embellish it came from the nearby deposits at Dolaucothi (Dyfed).

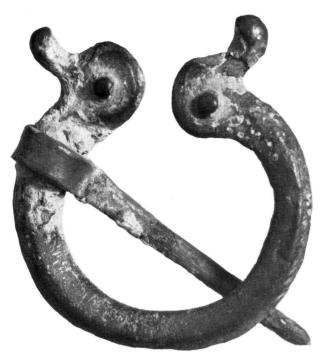

28 A Bronze Penannular Brooch
c 50-150 AD
Diameter 1in
2.4cm
Found in a burial deposit in the Big Covert
Cave, Maeshafn (Clwyd) in 1950. The brooch,
which shows traces of tin-plating, has
terminals which undoubtedly represent the
heads of ducks, birds which had a super-
stitious value in the old Celtic world and
were often represented, from the Bronze
Age onwards, on metalwork and pottery.

29 A Pattern for a Penannular Brooch
c 450-600 AD
Length 2in
5.1cm
Found in a sub-Roman nobleman's residence
at Dinas Powys, Glamorgan. This lead
model of one of the terminals of a large
penannular brooch, carrying on the tradition
of no.33 was probably used to form the clay
moulds for casting bronze brooches, with
patterns recessed for coloured opaque glass
on the terminals.

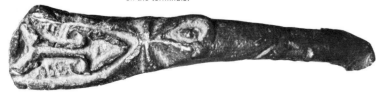

ox-head escutcheons but in the trumpet brooches of the 1st
and 2nd century AD, and the zoomorphic penannular
brooches of the 3rd and 4th centuries. In fact what is
probably the prototype of Romano-Celtic trumpet brooches,
a magnificent silver-gilt brooch with scroll patterns in good
British La Tène tradition cast in relief, was found recently at
Carmarthen close to the Dolaucothi gold mines; as there are
good reasons for believing that this brooch was made before
the Romans completed the conquest of South Wales, it
lends powerful support for the view already advanced, that
Early Iron Age Wales played an important part in the
production of British La Tène metalwork. The penannular
brooches, on the other hand, rather look forward to the
more elaborately ornamented brooches of this kind which
were produced in Early Christian Ireland and perhaps owe
their development in part to British craftsmen who crossed
the Irish Channel, like St Patrick, as refugees or slaves, and
joined the local craftsmen who still carried on La Tène
traditions. Such craftsmen also form the link between the
Cerrigydrudion bowl and those Early Christian 'hanging bowls'
found in pagan Saxon graves, whose enamelled escutcheons
revived the tradition of La Tène tripartite and whirligig
patterns in the 6th century AD.

H N Savory

30 A Fragmentary Penannular Brooch
c 250-350 AD
Diameter 1.2in
3cm
Found in an occupation deposit, mainly of
late Roman date, in the Minchin Hole Cave,
Penard, Gower. The surviving terminal of
this finely cast zoomorphic penannular
appears to be represented by the stylised
head and bill of an aquatic bird, facing down
the hoop of the brooch. It carries on the
tradition of no1 31 and is an ancestor of no. 33.

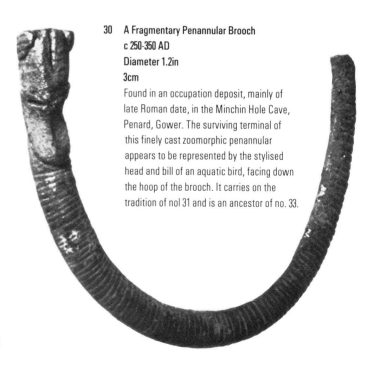

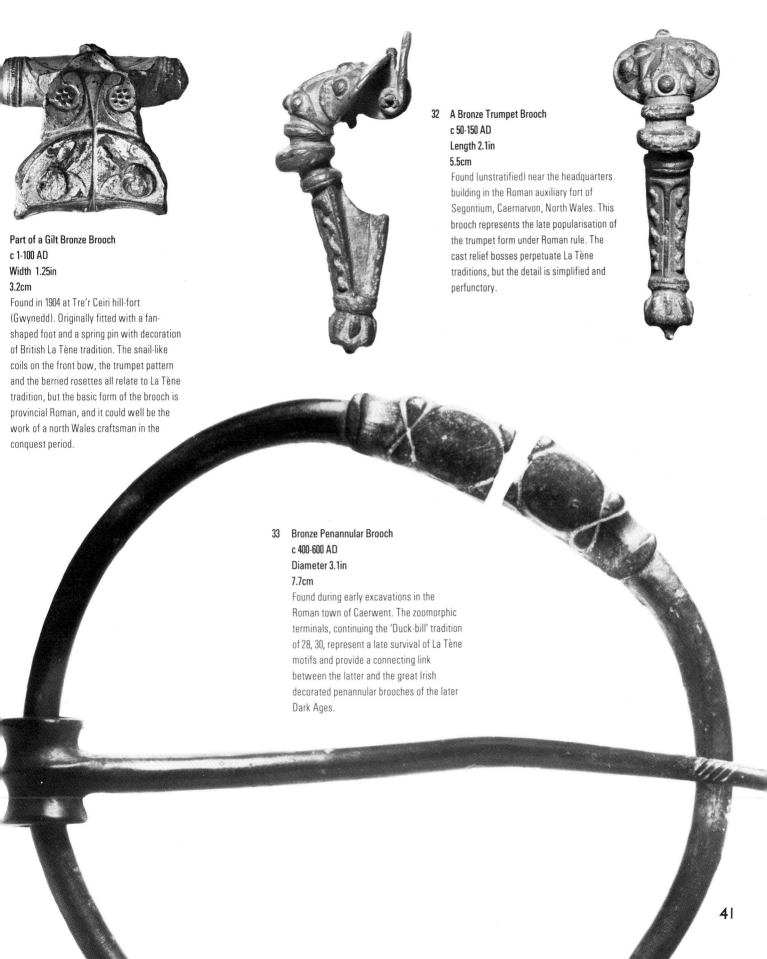

Part of a Gilt Bronze Brooch
c 1-100 AD
Width 1.25in
3.2cm

Found in 1904 at Tre'r Ceiri hill-fort (Gwynedd). Originally fitted with a fan-shaped foot and a spring pin with decoration of British La Tène tradition. The snail-like coils on the front bow, the trumpet pattern and the berried rosettes all relate to La Tène tradition, but the basic form of the brooch is provincial Roman, and it could well be the work of a north Wales craftsman in the conquest period.

32 **A Bronze Trumpet Brooch**
c 50-150 AD
Length 2.1in
5.5cm

Found (unstratified) near the headquarters building in the Roman auxiliary fort of Segontium, Caernarvon, North Wales. This brooch represents the late popularisation of the trumpet form under Roman rule. The cast relief bosses perpetuate La Tène traditions, but the detail is simplified and perfunctory.

33 **Bronze Penannular Brooch**
c 400-600 AD
Diameter 3.1in
7.7cm

Found during early excavations in the Roman town of Caerwent. The zoomorphic terminals, continuing the 'Duck-bill' tradition of 28, 30, represent a late survival of La Tène motifs and provide a connecting link between the latter and the great Irish decorated penannular brooches of the later Dark Ages.

41

the ROMAN OCCUPATION

The preceding section on the Iron Age will have made it clear that Celtic art was a European tradition, and that the modern geographical concept of *Wales* is an artificial one when dealing with early periods. In spite of the inevitable local differences in material culture, it has to be remembered that the inhabitants of a large part of northern Europe were Celtic, sharing similar customs and religious beliefs, speaking dialects of the same language, and showing the same aesthetic values in the production of their brilliant and distinctive art. The Roman rule which was imposed upon Celtic Europe at the beginning of our era brought about an extremely complex fusion in this as in other aspects of life, and before considering the place of Wales in this picture, with any local peculiarities it may have had, it is necessary to remind ourselves of the various threads which together wove the fabric of provincial Roman art.

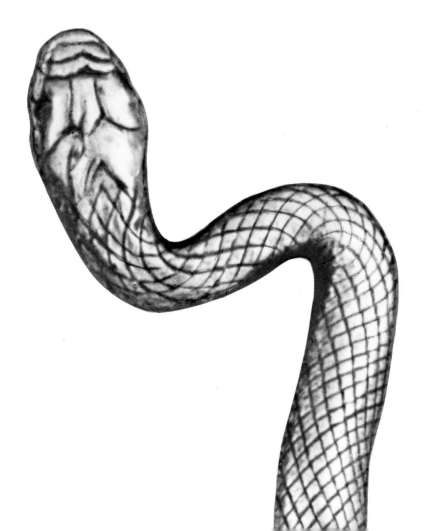

Detail of illustration 57

Detail of illustration 39

34 Stone Carving of a Mother Goddess
1st-4th century AD
Height 10.5in
26.7cm
Found at Caerwent in 1908, this figure shows a deity much worshipped in Roman Gaul and Britain. Sometimes a triple personification, sometimes single as here, most representations show some degree of Romanisation. This one is exceptional in its purely Celtic treatment, especially of the face. The goddess holds a tree and a fruit.

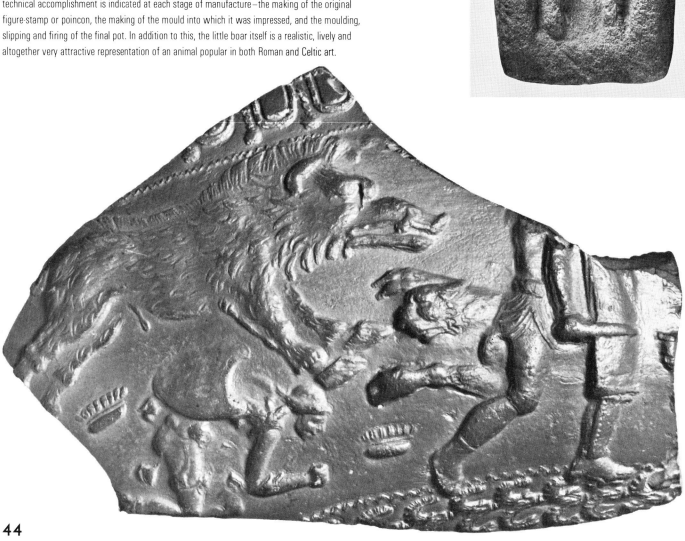

35 Fragment of Samian Ware
c 100-120 AD
Length of boar 2.625in
6.6cm
Found at Caerleon in 1927, the sherd comes from a hemispherical bowl made at Les-Martres-de-Veyre in Central Gaul by a potter we know as X-2 (his actual name is uncertain). His style is recognisable by details such as the ovolo (egg-and-tongue) ornament and the tiny 'crown' in the field. The boar figure-type illustrates the high quality of some decorated samian ware. High technical accomplishment is indicated at each stage of manufacture – the making of the original figure-stamp or poincon, the making of the mould into which it was impressed, and the moulding, slipping and firing of the final pot. In addition to this, the little boar itself is a realistic, lively and altogether very attractive representation of an animal popular in both Roman and Celtic art.

Throughout the centuries of development, from the dawn of the Iron Age north of the Alps to the time when the tribes of Gaul, and then Britain, succumbed to the power of Rome, the Celts had numerous contacts, friendly and otherwise, with the classical world. Rich Celtic chieftains fought and traded with their southern neighbours, and imports of Etruscan wine-jugs, Greek pottery cups and other exotic luxuries could not fail to influence the native art. La Tène craftsmen enriched their artistic vocabulary with classical motifs, but in their use of them, they always retained their own characteristic approach. By the first century AD, however, most of Celtic Europe had come under the direct political domination of Rome, bringing about profound changes in law, administration, language and a whole host of the details of everyday life. It is extraordinary that even in in these circumstances, Celtic characteristics, including language and art, continued as a powerful undercurrent, re-emerging in still recognisable form as the might of Rome receded. The objects which have survived to represent the art of this period of our history include some which are so purely Celtic in concept that the Roman invader might never have been present; there is no better example than the stone carving of a mother-goddess from Caerwent. Works as uncompromisingly Celtic as this are, however, far less common than those in which Celtic and classical have reacted upon each other in varying degrees and proportions. The background of Roman art is therefore directly relevant to our theme.

The fine arts as practised in Rome itself were firmly based on Greek traditions, and the best sculptors and painters were frequently of Greek nationality. Under the Emperor Augustus, who reigned at the turn of the first centuries BC and AD, art and architecture were closely modelled upon earlier Greek work, and though some aspects of Roman style (for instance, in portraiture) early developed highly distinctive traits, the Greek heritage continued to be of major importance.

But while the Latin language, Roman law and administration, and the forts, towns and villas which transformed Europe's countryside, spread over the Empire in a standard form, art was a different and less straightforward matter. One of the reasons for this concerns the relative importance of fine and applied arts at the centre of the Empire and in the provinces. The architecture, large-scale statuary and paintings executed by Greek masters in Rome for wealthy Roman patrons were far less relevant to Roman Gaul and Britain than the everyday utensils and ornaments which the Romans brought with them. These were often mass-produced objects, an important point to which we shall return. It is true that the good system of communications in the Empire meant that craftsmen could, and did, move from one area to another, and that major towns in the provinces would have done their best to emulate Rome in their public buildings and monuments by employing the best talent available. Nevertheless, the majority of Rome's conquered subjects would not have seen even the finest towns of their own country, and their experience of Roman style and taste would be based on simpler things.

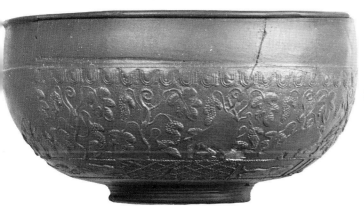

36 Part of a Decorated Samian Bowl
AD 65-80
This pot, found at Caerleon, was made in the workshop of a South Gaulish potter named Germanus. It is exceptionally clearly moulded, and shows a scene with vines, hounds and hares which is a spirited blend of Roman and Gaulish art.

37 Samian Ware Cup
Early 2nd century AD

This cup from Caerleon was made in Central Gaul by a potter called Ovidius; his name is stamped inside the vessel. Cups of this shape were also made in metal and glass, but are especially common in samian ware in the second half of the first century AD and the first half of the 2nd. Scores of other standardised shapes – bowls, dishes and cups – were made in this high-quality ware.

As we have seen, the Roman invaders found among the Celts a very strong national identity, and in Celtic art, something as capable of wielding influence as of absorbing it. As the Empire expanded, the Roman soldiers who served in Britain could just as easily be Spaniards or Gauls as Italians, and the Roman equipment imported by them had often been manufactured in these and other provinces rather than Italy itself. The cultural complexity of this situation was considerable, and it was increased by the important role of mass-production in the manufacture of many everyday Roman objects. For instance, some types of pottery and small bronze items (including military equipment) were made in workshops which had huge outputs and virtually Empire-wide distribution networks; sophisticated trading methods and regular army contracts both played their part in taking objects far from their place of origin. A mould-made samian pottery bowl manufactured in central France could have been transported to and used in areas as far apart as northern England, Italy or Hungary. Mass-produced, widely distributed and showing a fusion of Roman and native in its artistic style, samian ware well exemplifies

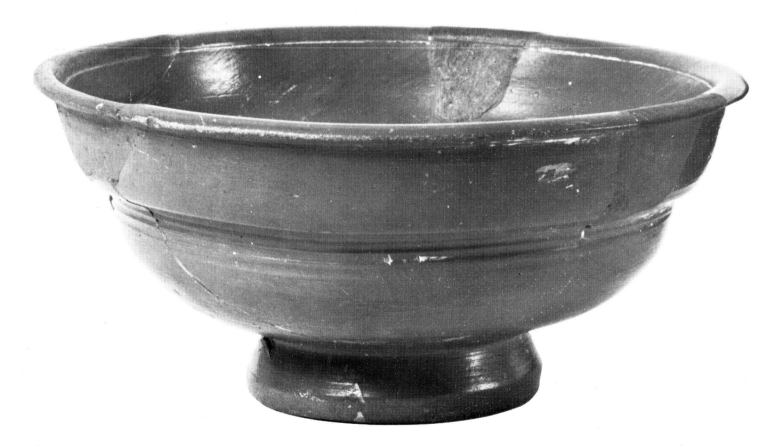

the points made above. Its forerunner was Arretine pottery, made in north Italy at the turn of the first century BC and the first AD, and very typical of Augustan art in its formal and idealised classical decoration. Little of this ware reached Britain, as it was no longer being exported in any quantity by the time Britain entered the Empire in AD 43. Samian ware, made in Gaul, followed on directly in the Arretine tradition, and for two centuries was imported into Britain in very large quantities. A bowl such as No. 36 from Caerleon is in many ways a typically Roman object: it is mass-produced in a mould in a large workshop, it shows great technical competence in manufacture, and it bears decorative motifs of impeccable classical antecedents. Yet it is also Gaulish, and though its Gaulishness is difficult to define, it would be obvious if the vessel were compared with an Italian one; the Hellenistic tradition has given way to the provincial artistic spirit. An object like this, which can truly be called Gallo-Roman, would be a normal representative of Roman art in Britain, and in its turn would influence Romano-British work, blending with the existing British Celtic tradition.

Gold Snake Bracelet
2nd-3rd century AD
Length circa 9.5in
24.1cm
This bracelet and no. 38 were found, together with gold necklaces, near the Roman gold-mines of Dolaucothi (Dyfed) in the late 18th century. Snake rings and bracelets were popular in Roman times; this one would originally have been curved in a spiral form. The workmanship is more delicate than a photograph suggests, and the golden reptile with its green glass eyes must once have been a splendid piece of jewellery.

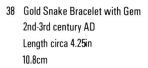

38 Gold Snake Bracelet with Gem
2nd-3rd century AD
Length circa 4.25in
10.8cm
This broken fragment was found near Dolaucothi with no. 39. It is a different type of snake bracelet, and the other half to which it was hinged is lost. The surviving snake's head, larger but not so finely worked as no. 39, confronts a hinged gold setting containing a sard.

Bearing in mind the complex nature of provincial Roman culture in general, and art in particular, the place of Roman Wales in this scheme of things can perhaps be seen in better perspective. The conquest of Wales was initiated within a few years of the invasion of AD 43, though it took nearly forty years for the Romans to secure the region, and the occupation remained predominantly military in character throughout the Roman period. Wales was a difficult area to subdue, with harsh terrain and determined, mainly ill-disposed inhabitants. Its subjugation was important to the Romans for more than the obvious reason of the security of the province as a whole: the mineral resources of Wales— gold, copper, iron and lead (from which latter silver could be extracted)—were highly desirable, and were exploited at the earliest opportunity. Though it is not normally possible to pinpoint the sources of the metals used in the innumerable objects of gold, silver, bronze, brass, iron, lead and pewter which survive from Roman Britain, we can feel sure that some of the fine gold jewellery found in Wales was made of metal mined at Dolaucothi in Carmarthenshire; 38 and 39

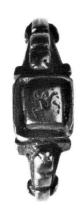
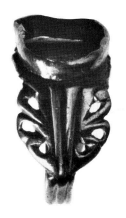
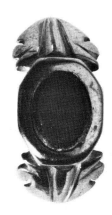

40 Four Gold Rings
3rd-4th century AD
The four rings were found in 1899 on Sully Moors, near Cardiff, and were associated with a hoard of coins, the latest dating to AD 306. The rings are all of characteristically late type. One is set with a small onyx cameo depicting a Medusa head.

41 Gold Ear-ring
Late 2nd century AD
Length .75in
1.9cm
Found at Caerleon in 1954. There are parallels to this design, with its two hemispherical sections, from Pompeii and elsewhere.

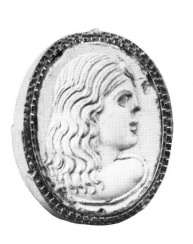

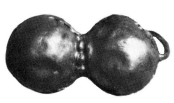

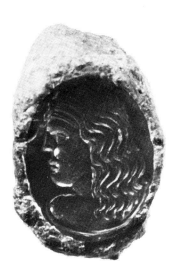

42 Iron Ring with Gem
2nd century AD
Length of gem 0.875in
2.3cm
Found at Caerleon in 1927. The stone, possibly jacinth, is engraved with the head of a woman with long, thick, wavy hair. The type appears to be derived from Hellenistic gems which show the head of a swimming nymph or marine goddess.

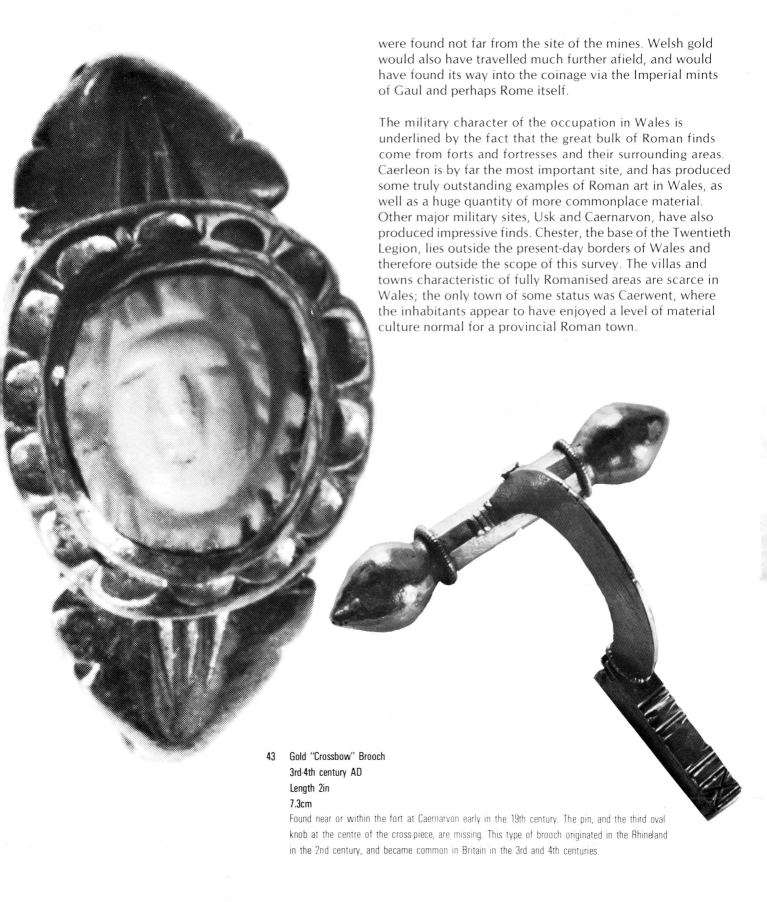

were found not far from the site of the mines. Welsh gold would also have travelled much further afield, and would have found its way into the coinage via the Imperial mints of Gaul and perhaps Rome itself.

The military character of the occupation in Wales is underlined by the fact that the great bulk of Roman finds come from forts and fortresses and their surrounding areas. Caerleon is by far the most important site, and has produced some truly outstanding examples of Roman art in Wales, as well as a huge quantity of more commonplace material. Other major military sites, Usk and Caernarvon, have also produced impressive finds. Chester, the base of the Twentieth Legion, lies outside the present-day borders of Wales and therefore outside the scope of this survey. The villas and towns characteristic of fully Romanised areas are scarce in Wales; the only town of some status was Caerwent, where the inhabitants appear to have enjoyed a level of material culture normal for a provincial Roman town.

43 Gold "Crossbow" Brooch
3rd-4th century AD
Length 2in
7.3cm
Found near or within the fort at Caernarvon early in the 19th century. The pin, and the third oval knob at the centre of the cross-piece, are missing. This type of brooch originated in the Rhineland in the 2nd century, and became common in Britain in the 3rd and 4th centuries.

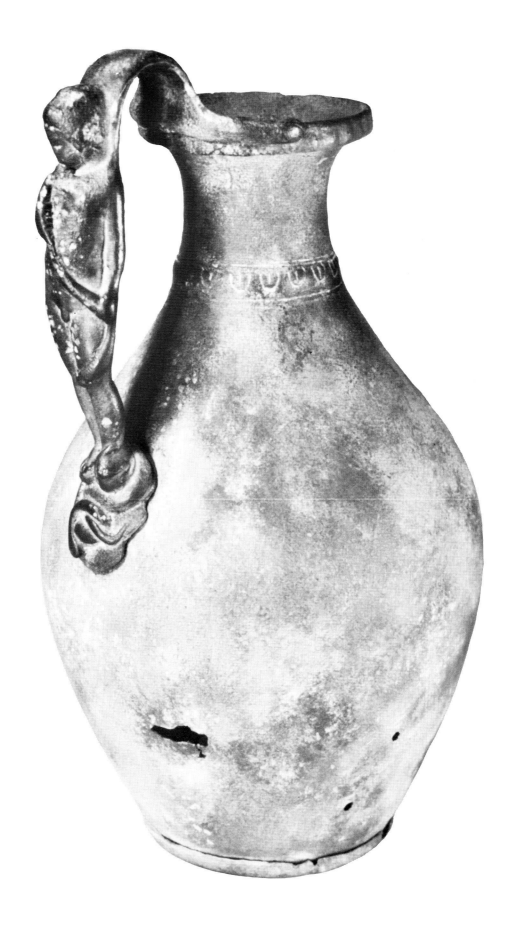

4 Bronze Jug
1st century AD
Height .925in
23.5cm

The rich burial found at Welshpool in 1959
produced, amongst other things, this jug,
the bronze dish (46) and the cow-head bucket-
escutcheon described by Dr Savory (24).
The shape of the jug suggests that it
was made in Italy. Vessels of this kind
usually have a strap-handle with decoration
in relief, but this handle is a figure in the
round, depicting the child Hercules having
just strangled the two serpents which Juno
had sent to kill him. Though it was later that
Hercules gained his lion's skin, he wears it
here and it forms the upper part of the
handle and the attachment to the rim of the
jug. In the myth, the hero was a young
infant at the time of the episode with the
snakes, but here he is shown as a
somewhat older child, probably because the
plump body of a baby would be unsuitable
to form a handle. This jug is an exceedingly
important and interesting object.

45 Gold Ring with Engraved Stone
2nd-3rd century AD
Diameter 1.5in
3.8cm

Found at Pentre, Rhondda, in 1929, the ring
was probably made in the Mediterranean
area. The intaglio is decorated with the
figures of Castor and Pollux.

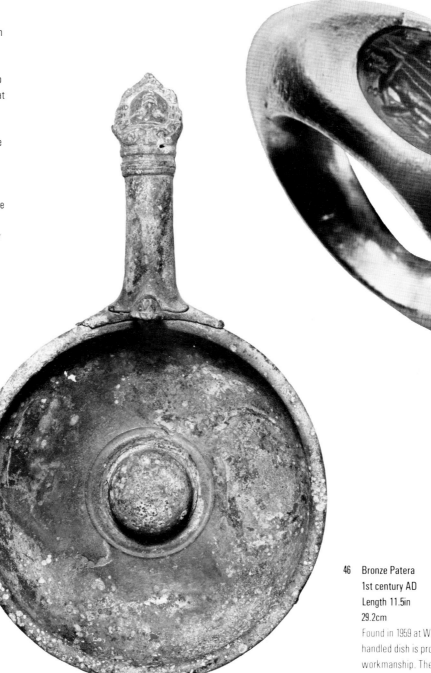

46 Bronze Patera
1st century AD
Length 11.5in
29.2cm

Found in 1959 at Welshpool. Like the jug, this
handled dish is probably of Italian
workmanship. The handle bears decoration
in the form of Bacchic motifs.

47 Bronze Stud with Enamelled Decoration
2nd century AD
Diameter 2in
5.1cm

A 19th century find from Pont-y-Saeson,
near Chepstow, Gwent, the stud was part
of a large bronzesmith's hoard of broken and
discarded objects destined for melting down
and re-use. Though damaged, it is patently
the twin of the Usk disc, and the two must
have formed a pair in use.

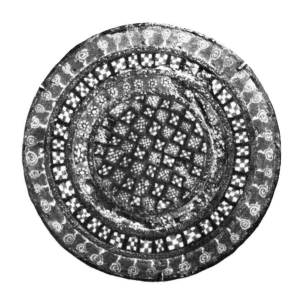

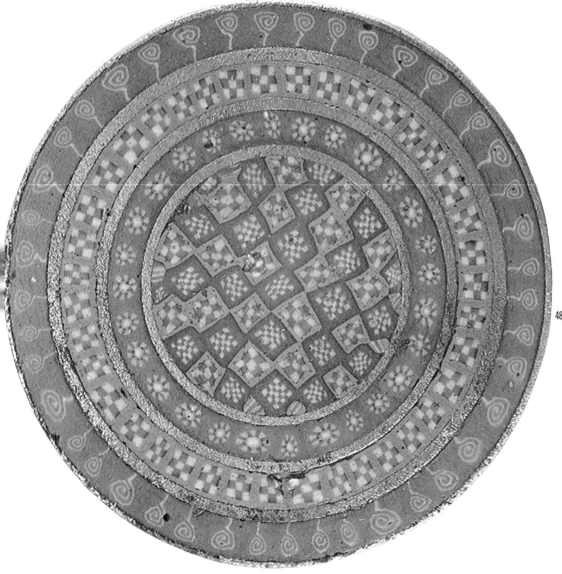

48 Bronze Stud with Enamelled
Decoration
2nd century AD
Diameter 2in
5.1cm

Found at the site of the fortress at Usk,
Monmouthshire. The disc is probably a
harness-mount, and its elaborate decoration
is of coloured glass, thin slices from rods of
glass mosaic having been applied to the
bronze backing. Though much enamelled
bronze was made in Roman Britain following
pre-Roman tradition, a piece such as this
would have been imported from the
Continent.

Bronze Dodecahedron
2nd-4th century AD
Height 4.125in
10.5cm

From Fishguard, Dyfed. These curious bronze objects are a well-known Roman type, but their use remains obscure. Candlesticks, dice and surveying instruments are among the theories which have been advanced. The holes in each of the twelve faces vary in diameter on all dodecahedra. The Fishguard example is unusually large and in fine condition.

Some of the objects illustrated in this chapter are not directly associated with Roman settlements, either military or civil, but are isolated finds. The splendid bronzes from Welshpool are from a rich burial, the late gold rings from Sully Moors were found with a hoard of coins, and the bronze stud with millifiori glass decoration from Chepstow, twin to the Usk stud, was from a bronzesmith's hoard, destined to be melted down and re-used. The bronze dodecahedron from Fishguard is a single stray find from an area notable for its lack of Roman remains, and it is interesting to note that another of these curious objects comes from Carmarthen. The apparent absence of Roman military establishments in the territory of the Demetae, south-west Wales, suggests that the invaders met with little resistance there and needed to exercise correspondingly little surveillance. The function of bronze dodecahedra, found in many parts of the Empire, remains a mystery, though various explanations have been put forward. These explanations range from the prosaic (candlesticks) to the more complex (surveying instruments). In any case, it is intriguing that one of the largest and finest examples of the type should come from such a non-Romanised area as the coast of Pembrokeshire.

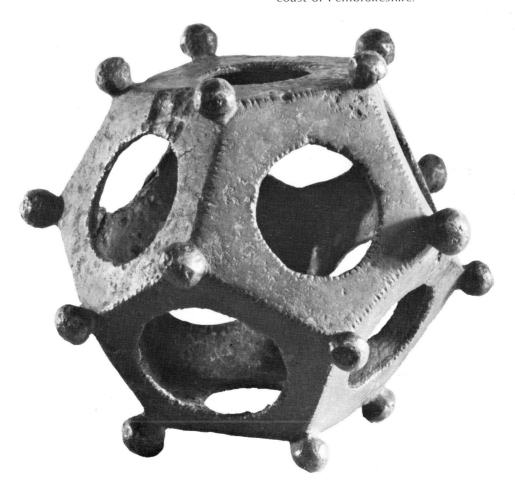

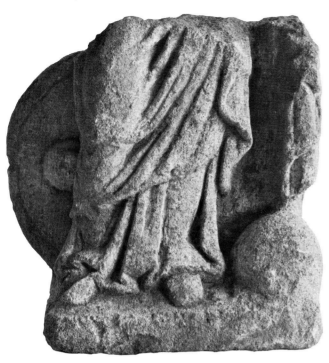

51 Painted Wall-Plaster
2nd century AD

Walls decorated with painted scenes and patterns were a purely Roman concept. Though too little of this plaster from Caerwent remains even to enable us to guess at the larger design of which it formed part, there is enough to judge that the work was of good standard.

50 Stone Statue of Fortuna
2nd-3rd century AD
Height 11in
30cm

This small statue, of which the upper part is unfortunately missing, comes from the Roman villa at Llantwit Major. The material is Bath stone, and the workmanship very good. The attributes of the goddess which survive are a globe, a wheel (of solid rather than spoked form) and probably part of a steering-oar.

Turning in rather more detail to some of the objects included in this survey, the relative lack of large-scale work, fine art and architectural material, is very striking. While this is in part due to the vagaries of archaeological survival, it must also to some extent reflect the situation in Roman times. Most of the better examples of stone statuary are very fragmentary or in poor condition, and thus unsuitable for illustration here. The figure of Fortuna from the villa at Llantwit Major, is fairly complete and it is of interest that it seems originally to have formed a pair with a similar small statue of a Genius, now surviving only in very small fragments. Mosaics and wall-paintings, both common in Roman Britain, are poorly represented, though what remains is of good quality. The mosaic from Caerwent is composed of local stones and fragments of tile and pottery, and though its style is crude and unsophisticated, it has considerable vigour. The remains of the labyrinth mosaic from Caerleon, however, belong to a very widespread type, with examples known from as far afield as North Africa. The maze pattern is often associated with illustrations from the story of Theseus, Ariadne and the Minotaur, and it is clear that the design is intended to represent the Cretan labyrinth itself.

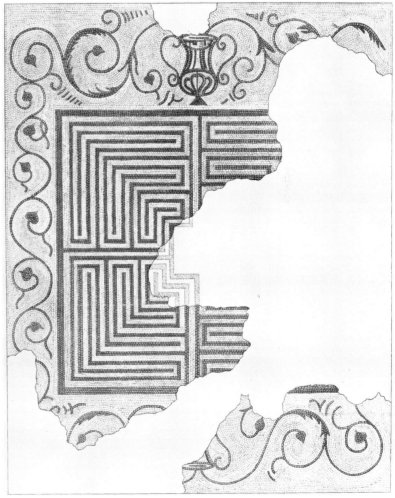

52 Labyrinth Mosaic
3rd century AD
Labyrinth pattern 8 ft square
244cm
This portion of mosaic was found at Caerleon in 1865. As the central area is missing, it is not possible to say whether it may, like many mosaics of this pattern, have contained a figure relating to the legend of Theseus and the Minotaur. Examples of the design are known from many parts of the Roman empire, and this is one of three British specimens.

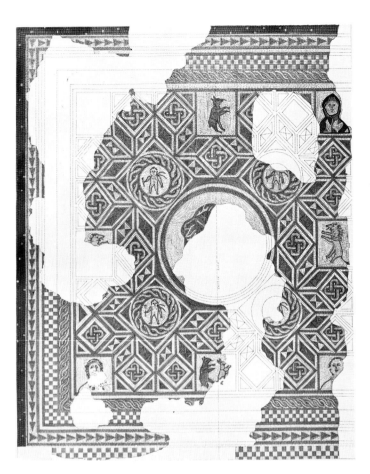

53 Fragment of Mosaic Pavement
4th century AD
This is a small area from a pavement decorated with geometric motifs and some figures, including busts of the Seasons, a common theme on mosaics. This portion depicts Winter. The work is clearly local (the materials used are tesserae of local stones and pottery) and fairly crude, though not unusually so for its late date.

54 Inscription on Stone
AD 198-209
43 x 17 x 1.5in
This inscription is carved on sandstone, and records re-building at Caerleon. It was found between 1845 and 1850.

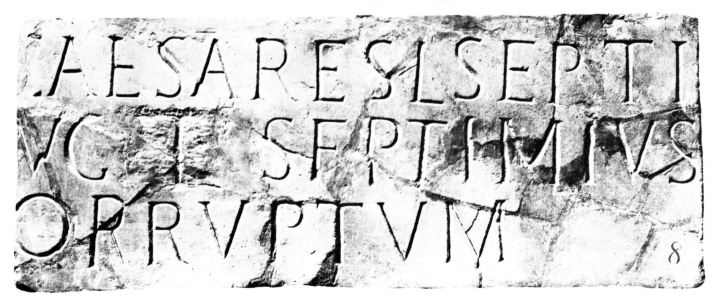

As the central panel of the Caerleon mosaic is missing, it is unknown whether or not it contained a scene from the Theseus legend. Wall-paintings seldom survive in good condition, and their restoration is such a difficult and time-consuming process that few are complete enough to provide useful comparisons; the Caerwent fragment seems to be of quite a high artistic and technical standard.

Of other large-scale work, inscriptions on stone should be mentioned. These, generally associated with military sites, are well represented in Wales, and the three from Caerleon illustrated here have been picked to show the development of lettering on stone from the late first to the third century. They serve, too, to remind us that the introduction of widespread literacy was one of the many changes in daily life brought about by the Romans. As the following chapter will show, the Latin language survived in use for some considerable time after the Roman occupation, on memorial stones and crosses of the Dark Ages.

55 Inscription on Stone
100 AD
58 x 47 x 4in
This marble building-inscription, still bearing traces of red paint picking out the letters, was found at Caerleon in 1928. It had been re-used as a paving-stone in later Roman times. Lettering of this period, under the Emperor Trajan, is considered the finest of all Roman styles.

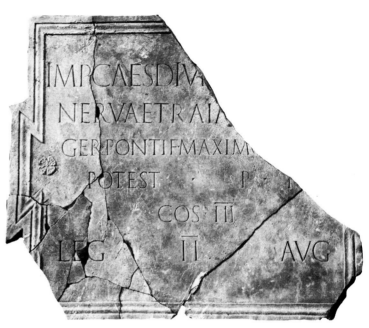

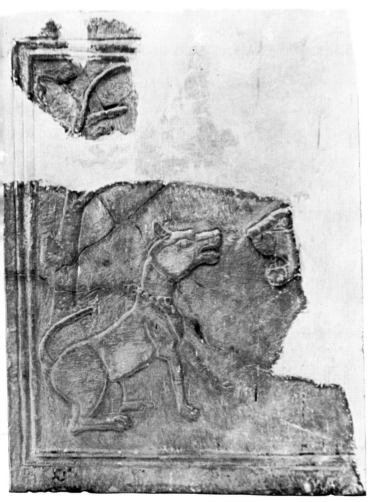

56 Stone Relief Sculpture
2nd-3rd century AD
Height 39in
9cm
This relief, from Caerleon, is carved in local stone, and shows a large dog attacking a wild animal, probably a lion. This type of subject is common in Roman art, but the style of this piece is provincial, though lively and competent. Britain was noted in Roman times for a breed of large hound.

57 Inscription on Stone
AD 255-260
37 x 28in

This inscription on sandstone commemorates the restoration of barrack-blocks under the Emperors Valerian and Gallienus. It was found at Caerleon in the early 19th century. The change in the style of lettering from that on the earlier inscriptions is very marked.

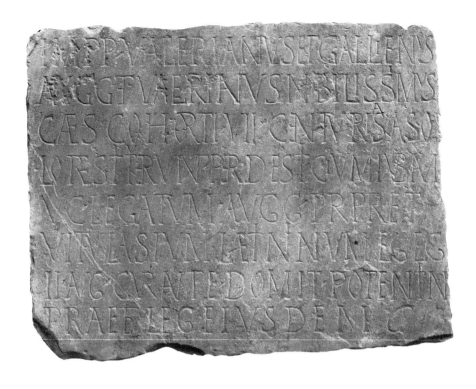

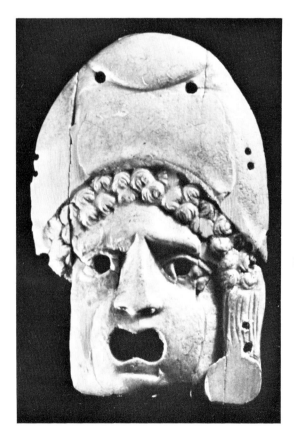

58 Ivory Mount
2nd-3rd century AD
Height 4.25in
10.8cm

This mount from Caerleon is an ornamental plaque from a box or casket, carved in the form of a tragic mask wearing a Phrygian cap. It is a small masterpiece, and has no parallel in Britain. Bone was very widely used in Roman Britain, but ivory objects were seldom imported.

58

Especially important among the outstanding exotic objects from Roman Wales are the two ivories from Caerleon. While bone was very frequently used in Roman Britain for a variety of small useful and ornamental objects, imported ivory is rare, and there is nothing else in the country to compare with these two small plaques, which probably served to decorate a box or casket of some kind. The tragic mask is of high artistic quality, as is another object from Caerleon, the agate cameo with a head of the young Hercules. Other very attractive pieces occur amongst the considerable quantity of Roman jewellery found in Wales. Dr Savory has discussed the magnificent trumpet-brooch from Carmarthen and though some fine examples already exist of this type of brooch, for example the silver-gilt pair from a hoard found at Backworth, Northumberland, and the silver specimens from Chorley, Lancashire, the Carmarthen brooch is undoubtedly the standard by which all the others must now be judged. The gold bracelets from Dolaucothi already mentioned and the bracelet and collar from Rhayader are all excellent pieces of jewellery by any standards, and add to the impression that, though Wales may not have enjoyed quite the level of sophistication south-east England knew in the Roman period, plenty of individuals possessed luxury articles which would have been highly regarded in any part of the Empire.

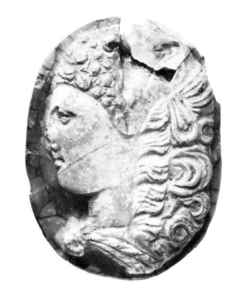

59 Agate Cameo
 1st century AD
 Height 1.125in
 2.7cm
Found at Caerleon in 1883. The finely-carved, youthful head wears a lion's skin, and therefore represents either the young Hercules or Omphale, who is also shown with this attribute owing to her association with Hercules. Roman cameos are very rare in Britain.

Gold Necklet or Bracelet
2nd-3rd century AD
Length circa 10in
25.4cm
Found near Rhayader, Powys, with (67). The red and blue stones are set on separate rectangular plates of thin gold, and surrounded with simple filigree. The narrow gold plates are decorated with peltae (Amazons' shields). This piece would originally have been attractively bold and colourful, but is now much damaged.

61 Ivory Mount
 2nd-3rd century AD
 Height 3.875in
 9.8cm
This rectangular plaque, found with the tragic mask (58), shows a draped female figure, perhaps a dancing Maenad, holding a large basket of fruit which is balanced on the head of a small boy or Cupid. While this carving does not have the artistic impact of the mask, it is still an attractive piece of work.

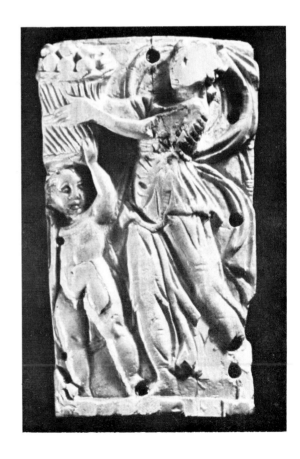

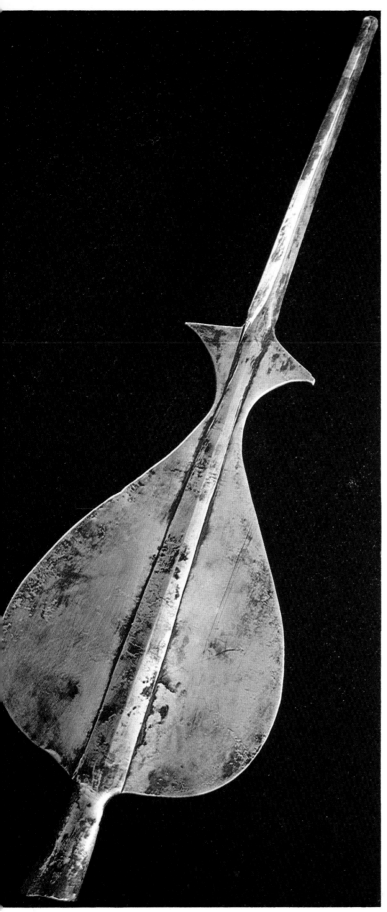

62 Silver Standard-head
2nd-3rd century AD
Length of blade 11.25in
28.5cm

Found in 1928 during the excavation of the
legionary hospital at Caerleon, the standard-
head is in the form of a stylised spearhead.
The type is known from sculpture reliefs
and miniature representations, and there
are some surviving examples in bronze and
iron, but the Caerleon piece is the only one
known in silver. The standard-head was an
emblem of high office.

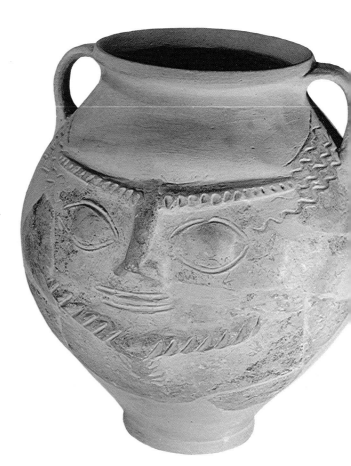

63 Pottery Face-urn
2nd-3rd century AD
Height 8.75in
21.6cm (restored)

The fragments of this vessel, now restored, were found at Caerwent in 1923. In Britain, face-
urns like this were made at Colchester, and the type is common in the Rhineland; this is the
only example from Wales. However simple the element, the faces are always expressive and
vigorous, and are often considerably more grotesque than this one. Sometimes phallic
ornaments are added, suggesting that some fertility aspect may be involved.

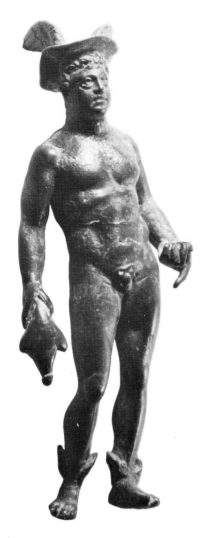

Wales has not yet contributed to the number of late Roman silver vessels found in Britain, except for one skillet of somewhat uncertain history and date (in the British Museum). The Welshpool burial has, however, produced two bronze vessels of the greatest interest and artistic distinction. Though this jug and patera 44; 46 are probably of Italian origin, the same burial contains objects of Gaulish and British manufacture, the latter including the fine ox-head bucket-escutcheon discussed by Dr Savory.

As in the pre-Roman Iron Age, small objects of bronze abound but relatively few of these can be classed as art. Statuettes of deities are common, and the Mercury from Caerleon is a better piece than most; silver and silvered-bronze statuettes are very much rarer than plain bronze. Enamelled bronze is common for small useful objects such as brooches, and with the tradition of enamelling which existed before the conquest, there is no doubt that much of such work is native. The pair of studs from Usk and Chepstow, 47; 48 however, make use of the delicate technique of enamelling with a slice of glass mosaic from a patterned glass rod, and were made on the continent, probably in the area of Gaul which is now Belgium. The precise function of the two studs is not clear, but they form an identical pair, and we may assume that the one found at Usk was lost first; the second one then being useless, its owner traded it to a bronzesmith.

Glass vessels were also made in the millifiori and other polychrome techniques, and Caerleon has produced several fragments of such bowls; none is really suitable for illustration here. Another rare and interesting glass vessel from Caerleon, a mould-blown beaker in the shape of a negro's head, is also unfortunately too fragmentary to be shown. The sherd of an engraved glass bottle, another very unusual type, gives only a sketchy idea of the original appearance of the vessel. Roman glassware of the more common kinds, sturdy bottles and bowls in light green and brownish shades of glass, is abundant at Caerleon and other Welsh sites.

64 Bronze Statuette of Mercury
2nd-3rd century AD
Height 4in
10.1cm
From Caerleon. The statuette was originally silver-plated, and traces of the plating remain. The god is recognisable by his winged shoes and hat, and the purse he carries in his right hand. His left hand would have held the *caduceus*, a staff, often winged, entwined with serpents. The style of the statuette indicates Gaulish manufacture.

65 Fragment of Glass Bottle
3rd-4th century AD
Probably original height c 7.125in
18cm
These joining fragments form the lower part of a glass vessel of globular shape with a slender cylindrical neck. They were found at Caerleon. The decoration is cut and engraved, and though too little remains to identify the scene as a whole, parts of five human figures and an animal can be made out. Glass vessels with this type of decoration are very rare.

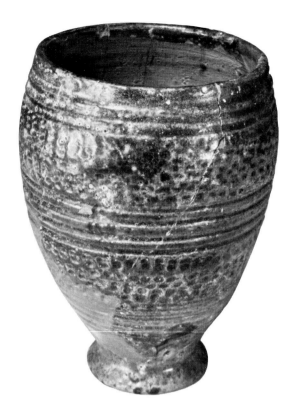

The final category of material is pottery. All Roman sites produce pottery, many in immense quantities. The precise definition of *art* is something of a problem here, because by some standards, the coarsest cooking-pots might be felt to qualify as well, or better, than ware which in its own time was considered superior. The pottery illustrated is chosen to show some of the more striking pieces imported from Gaul and made at the legionary potteries in Wales. Imported pottery is represented by samian ware, though there were other types which came in from Gaul, Germany and even Spain, some of them very skilful work indeed. Legionary potteries such as those of the Twentieth Legion at Holt in Denbighshire produced a variety of wares, ranging from tiles and roof-ornaments to exceedingly fine vessels like the bottle illustrated. The Holt potteries made lead-glazed vessels as well as the more usual unglazed wares, but the beaker from Caerwent may well be Caerleon (Second Legion) legionary ware. Also from Caerwent is the handsome face-urn, which is the only example of its type from Wales. These urns, often used as containers for cremated bones, are most characteristic of the Rhineland, but they are known to have been made in one area of Britain at least, at the potteries in Colchester.

66 Glazed Pottery Beaker
1st century AD
Height 4.125in
10.5cm
Found at Caerwent in 1947. Some lead-glazed pottery was imported from Gaul early in the Roman occupation, but it was later made in Britain at potteries which included the legionary kilns at Caerleon and Holt. This example may have been made at Caerleon. Whether or not provided with the extra refinement of a vitreous glaze, simple pottery vessels of this kind, manufactured in huge quantities, have the basic appeal of useful, functional objects.

67 Gold Bracelet
2nd-3rd century AD
Width 1.25in
3.2cm
This bracelet was found, together with the necklet (60) and a large gold ring, near Rhayader, Powys. The decoration is executed in plain and beaded gold wire, while the delicate scroll pattern on the hinge plates is picked out with green and dark blue enamel.

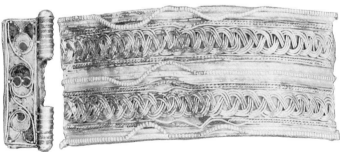
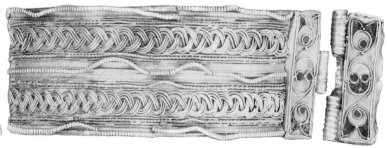

8 Pottery Antefix
2nd century AD
Height 8.375in
20.8cm
From Holt, Clwyd, where the kilns of the
Twentieth Legion were situated. Decorated
triangular tiles of this kind were used as
roof embellishments on buildings. The
design of this example includes a military
standard and the figure of a boar, badge of
the Twentieth Legion.

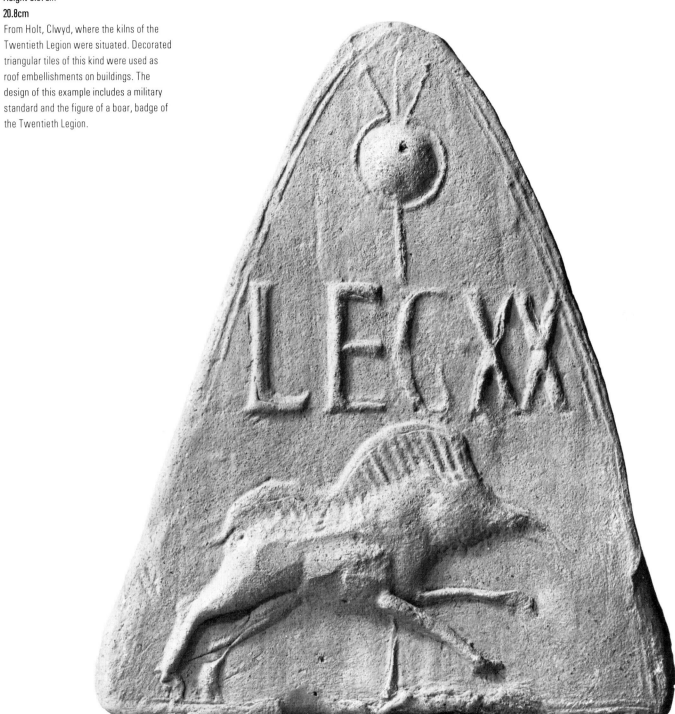

69 Pottery Bottle
Early 2nd century AD
Height 7½in
19.2cm
This vessel is an example of the good
quality pottery produced at the Twentieth
Legion's kilns at Holt, Clwyd.

The final impression which emerges of art in Wales under the Romans is richer than might be expected. Under a predominantly military occupation, Wales never achieved the degree of material comfort which existed in some areas of the island: nevertheless the inhabitants became thoroughly familiar with all the typical trappings of Roman life, and could not fail to absorb the standards of taste normal in any province of the Empire. Together with the rich native heritage of Celtic art, this provided an unbroken tradition which continued and developed further in the Dark Ages following the retreat of Rome.

Catherine Johns

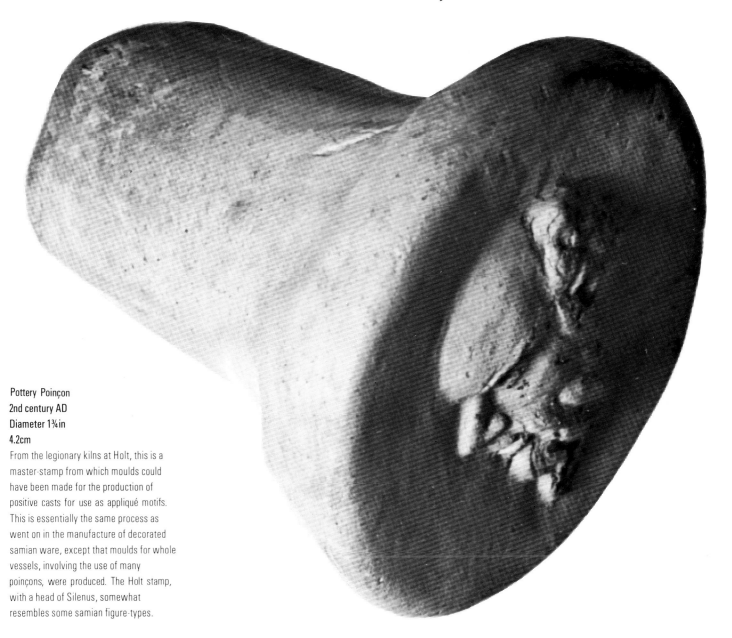

Pottery Poinçon
2nd century AD
Diameter 1¾in
4.2cm

From the legionary kilns at Holt, this is a master-stamp from which moulds could have been made for the production of positive casts for use as appliqué motifs. This is essentially the same process as went on in the manufacture of decorated samian ware, except that moulds for whole vessels, involving the use of many poinçons, were produced. The Holt stamp, with a head of Silenus, somewhat resembles some samian figure-types.

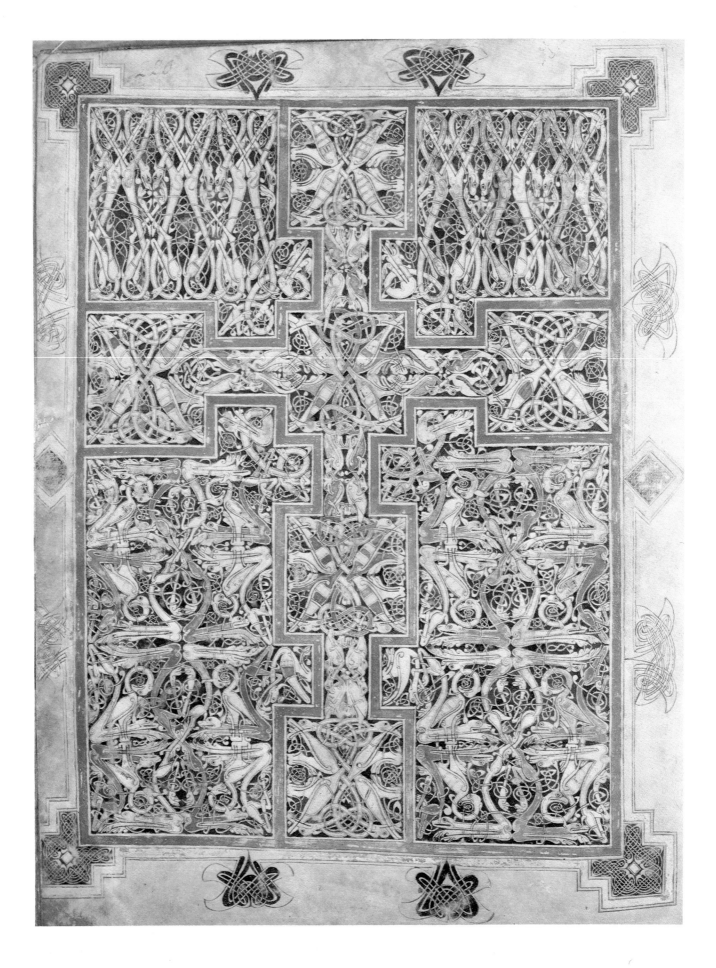

early christian wales

When comparisons are made with other periods, it has to be admitted that the remains of Early Christian art in Wales are relatively sparse, and are, moreover, extremely limited in their range. Monuments of stone comprise the largest single category. In much smaller quantity there are metal objects such as bells, brooches, armlets and pins, and fragments of several kinds of pottery; a few small articles of bone and stone complete the selection. Almost all the stone monuments can be shown to have had a religious or a funerary purpose, and many of the small finds belong to a religious context.

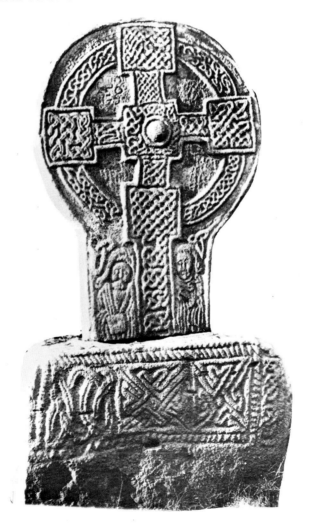

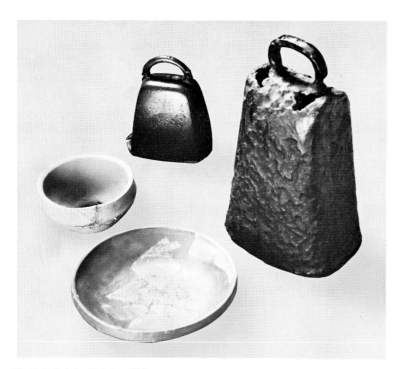

The time with which we are concerned embraces some seven hundred years—from the end of the Roman occupation to the arrival of the Normans. Historical nomenclature has varied: the earlier part of this period—or even the whole—has been called the *Dark Ages*, owing to the dearth of historical evidence. Another proposed designation is *Early Medieval*. But in the Celtic west of Britain the character of the period is well described in the term *Early Christian*, and this is used in the present article.

It may be questioned whether this dearth of evidence is genuine, or merely the result of insufficient investigation. After all, few Early Christian sites have actually been identified in Wales, and fewer still have been archaeologically excavated. Of course there are many localities traditionally connected with early Christianity, as witness numerous place-names containing the element Llan (= church) and the name of a local saint, but this is no help to the art historian. Early illuminated manuscripts seem to have been particularly ill-fated in Wales; many have survived elsewhere in the British Isles and in Europe, but there are hardly any which can be given a Welsh context.

The climate of Britain has never favoured the preservation of articles made of wood, cloth, leather or basketry, but objects of stone, bone, metal and pottery are plentiful in the

73 Early Christian Finds from Wales:
Pottery and Hand-bells

a Bowl of grey ware, with impressed roulette decoration, probably from the Bordeaux area. Found in a hill fort at Dinas Powys, South Glamorgan. Date AD 450-650.
Diameter 5.5in, 140mm

b Bowl of red ware with circular pattern of 'leopards' in centre, from the eastern Mediterranean. Date probably 5th century. Found in a hill-fort at Dinas Powys, South Glamorgan.
Diameter 8.875in, 226mm

c St Gwynhoedl's bell, made of cast bronze, with animal-headed terminals on handle. From Llangwnnadl Church, Gwynedd. Date 9-11th century.
Height 6.75in, 170mm

d St Ceneu's bell, made of wrought iron. From the site of St Ceneu's Chapel, Llangenau, Powys.
Height 12in, 310mm

Preceeding pages

71 **The Gospels of St Chad**
A decorated page showing an outline cross on 'carpet' design (page 220 of manuscript)

72 **The Cross of Conbelin (Cynfelyn)**
Late 9th-early 10th century
Height 88.5in
2.25 metres

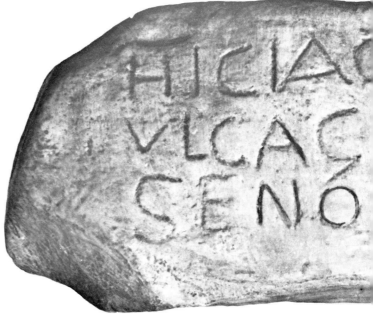

archaeological record of many periods. Thus the scarcity of the more durable bric-à-brac of daily life, not to mention works of art, relating to the Early Christian period suggests a low material standard of living.

The previous contributor has remarked on the two contrasting areas of Roman Wales. Much of the west and the interior escaped the full impact of Romanisation, in spite of the presence of Roman influence in the shape of military outposts. The eastern border and southern coast, however, bore signs of successful Roman penetration, characterised by town and villas. There, throughout the occupation, sophisticated architectural forms in stone, wood and tiles were to be seen. The realisation of these forms depended on geometry and accurate measurements applied on a large scale. Decoration, too, required geometry and measurements; it included much abstract pattern, but human and natural forms were really at the centre of Roman artistic interest.

For reasons which need not be enumerated here, this Roman way of life began to disintegrate in the early fifth century. The inhabitants of Britain perforce reverted to less sophisticated habits, in particular to a way of looking at the world which did not depend on naturalistic pictures and images. They used less ambitious skills and materials to make their homes, vehicles, boats and utensils.

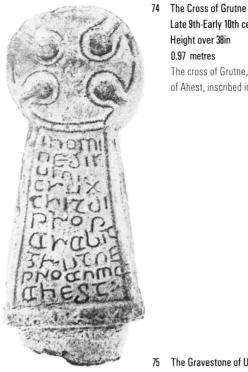

74 The Cross of Grutne
Late 9th-Early 10th century
Height over 38in
0.97 metres
The cross of Grutne, prepared for the soul of Ahest, inscribed in half-uncials.

75 The Gravestone of Ulcagnus
5th-early 6th century
Height 48in
1.22 metres
The gravestone of Ulcagnus, son of Senomaglus, inscribed in Roman capitals.

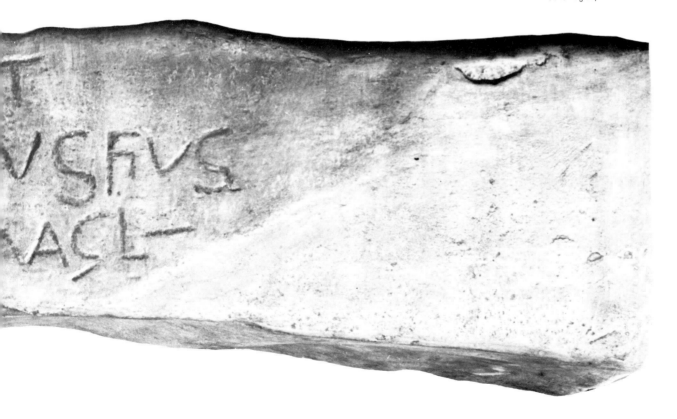

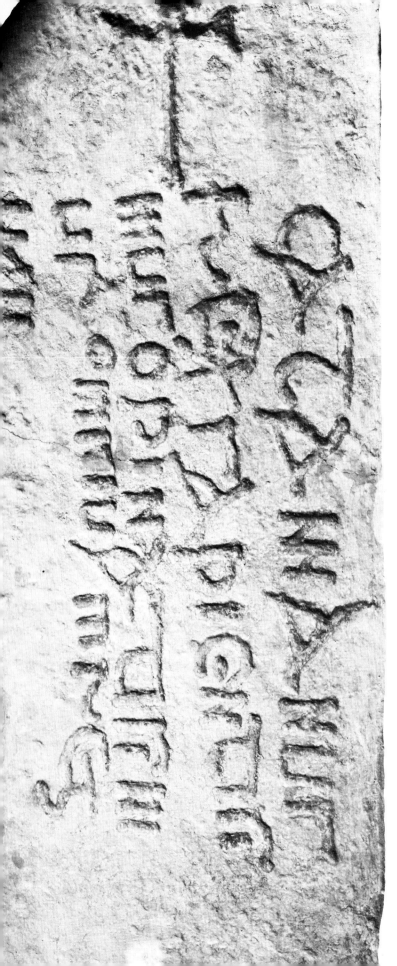

New artistic influences there were, late classical in character. They were transmitted to Britain by roundabout routes from North Africa and from the eastern Mediterranean, where the Byzantine part of the Roman Empire continued to flourish. The indigenous tradition of prehistoric art, itself embodying earlier classical influence, had survived in Britain through the Roman period and was now a decisive factor, especially under Irish inspiration. Abstract or stylised forms were dominant. Geometry was harnessed not to large-scale practical technology, but to smaller-scale objects for personal use or devotional purposes. Overseas trade in objects of art and craft did not cease, though it was much reduced; new kinds of pottery originating in Mediterranean areas and in Gaul appeared in Wales. Movement around the western coasts seems even to have increased, but the vessels —which could have been little more than small boats—were laden not so much with goods, but with Christian saints and doctrine, the poet Gwenallt's *marsiandïaeth Calfari*.

The greatest abiding legacy was the Latin language and Roman writing. The use of Roman capital letters for monumental inscriptions continued after the Roman occupation during the fifth and sixth centuries. But little by little this lettering was influenced by the cursive or written hand, as used on the Continent, and by the Greek alphabet. A new style of rounded letters (far less suitable for stone carving) became established by the early seventh century: this was the Celtic half-uncial hand, later known as *Hiberno-Saxon*. It contrasted with the angular style of the Merovingian hand, derived from Runes, an alphabetic system of northern Europe. This Runic style, curiously enough, later became popular for the title-pages of Celtic illuminated manuscripts.

Knowledge of the Roman alphabet seems to have inspired the Irish to invent one of their own for monumental inscriptions. Known as Ogham, it was based on combinations of strokes and notches made along the edge of a stone; when the stone was set up, the inscription would read upwards. Irish immigrants evidently brought this form of writing into the western peninsulas of Dyfed and Llŷn, for numerous Ogham-inscribed stones are found in those parts.

76 The Gravestone of King Cadfan
 of Gwynedd
 AD c. 625
 Height 48.25ins
 1.23 metres
 Inscribed in mixed Roman capitals
 and half uncials

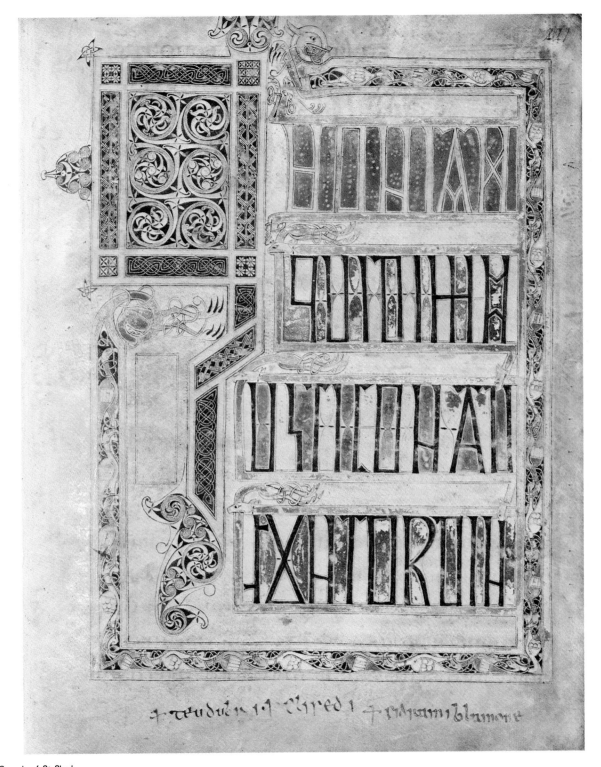

77 The Gospels of St Chad

A page of illuminated letters from the
Gospels of St Chad, showing Celtic
curvilinear decoration and angular letters
with Runic affinities (page 221 of manuscript)

The earliest Christians drew their inspiration from the word rather than the image, and this at first inhibited the growth of an iconographic tradition. As the faith spread, and especially when it was officially recognised in the early fourth century, its followers felt free to adapt pagan art to their own purposes. Christ in Majesty, for example, came to be visualised in the same image as the Roman Emperor.

Symbols were important. While Christians were still persecuted, they used the outline of a fish as a secret sign; its letters in Greek, IXΘYC, made the initials of a statement of belief, *Jesus Christ, Son of God, Saviour.* The cross itself was at first little used, since it was regarded as a degrading symbol of pagan punishment. But a not dissimilar pattern, composed of the first two letters of the Greek name of Christ, XP, was widely used; this was the chi-rho monogram, and it took various forms: ✳ ⳨ ✝

79 A Cross at Llanfihangel Cwm Du
Possibly 7th-9th century
Length 48in
1.22 metres
Incised outline of a Latin cross with splayed terminals.

78 Ring cross, St Non's Chapel
5th-7th century
Height of stone 43.5in
1.1 metres
A simple ring-cross on a slab used in the wall of St Non's Chapel near St Davids, Dyfed.

80 The Pen-y-fai Cross
Late 10th or 11th century
Height 50in
1.27 metres
Cross of 'panelled cartwheel' type, probably
marking a boundary. Found at Pen-y-fair,
Mid Glamorgan.

81 The Stone of Anatemor
5th - early 6th century
Height 74in
1.88 metres
Anatemor is described as the
son of Lovernius.

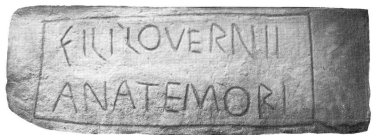

73

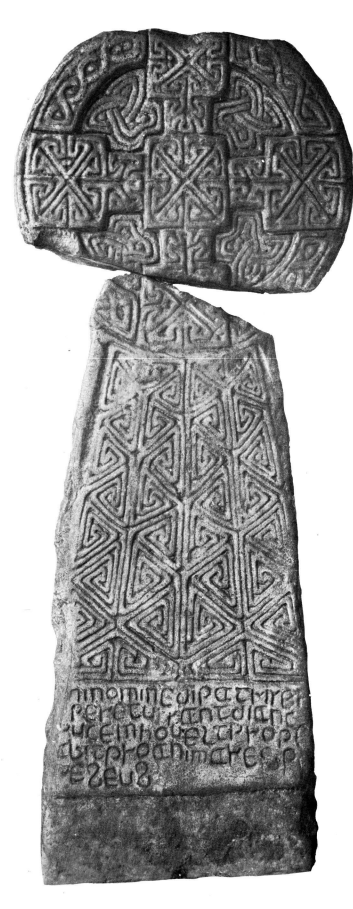

A fourth-century version of this monogram has been discovered scratched on a pewter dish from the Roman town of Caerwent in Gwent. Another form can be seen on the fifth-century tombstone of Carausius from Penmachno, and yet another on a round piece of pottery dated between 450 and 550 AD, found in the Dark-Age hill fort of Dinas Emrys in Gwynedd.

When distaste for the true cross began to disappear, different versions of its outline came into general use. The ring cross (like the pattern of a hot cross bun) was already common in the Celtic west and seems to have arisen as an artistic development of the chi-rho symbol, eventually combining with the Latin cross to give the outline characteristic of the Irish high crosses. It is possible to read some symbolism into the geometric elements of Early Christian art, for example the idea that a circle represented eternity, but we are here on rather speculative ground.

With this background we can begin to appreciate the main artistic achievement of Early Christian Wales, the stone monuments. Some 450 of these were catalogued in great detail in 1950 by Dr V E Nash-Williams. They are distributed throughout Wales, thinly in the interior and eastern border, but thickly in the Isle of Anglesey, the peninsulas of Llŷn and Dyfed, and along the coast of Glamorgan. A dozen or so have been discovered since 1950, but they make no significant difference to the pattern of distribution.

Making generalisations covering 700 years on a basis of little more than 450 pieces of evidence can present difficulties and pitfalls. However, certain facts are clear about the monuments. Many bear inscriptions showing that they were made to mark a burial; others were erected to commemorate individuals, though not explicitly on the site of their graves. Some were praying-stations, others marked the location or limit of a parcel of land or monastic estate; a few may have belonged to altars. Where no inscription exists, the purpose of a monument is bound to be debatable, especially if it has been found out of its original context.

82 The Cross of Houelt (Hywel)
Late 9th century
Height 72in (above butt)
1.83 metres
The cross of Houelt (Hywel) which he prepared for the soul of his father Res (Rhys), with inscription in half-uncials.

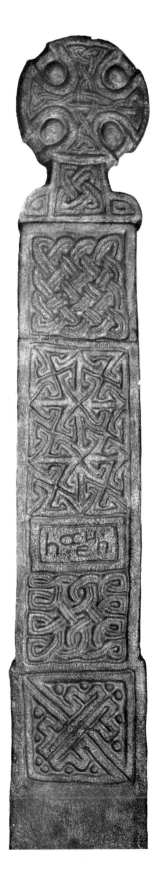

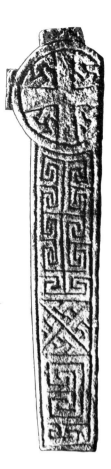

83 A Cross at Penmon
Late 10th-11th century
Height over 85in
2.16 metres
Cross at Penmon, Anglesey, decorated on
all four sides (one ear of cross-head broken).

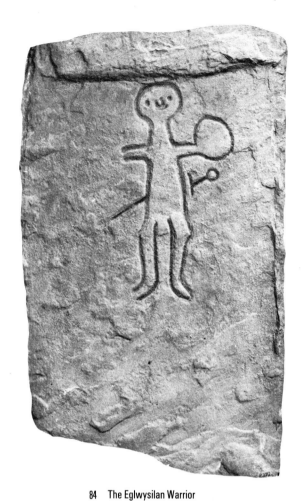

84 The Eglwysilan Warrior
Possibly 7th-9th century
Height of slab 27in
0.69 metres
Sketch of a Dark-Age warrior incised on
a slab. Found in Eglwysilan Churchyard,
Mid Glamorgan.

85 A Cross at Nevern
Late 10th-early 11th century
Height 156in
3.96 metres
A cross decorated on all four faces; one of
the most majestic of the Welsh carved
crosses.

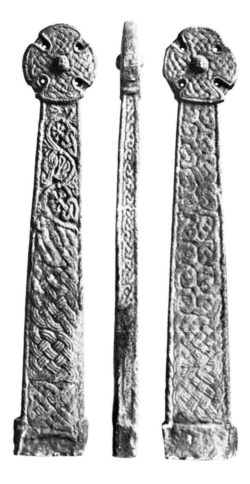

86 A Cross at Penally
First half of 10th century
Height 84 in
2.13 metres
A cross with wheel-head and slender shaft;
perhaps the most graceful of all the Welsh
carved crosses.

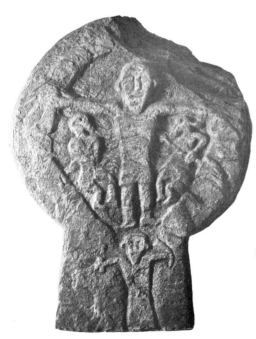

87 The Llangan Crucifixion
10th–11th century
Height of cross over 51 in
1.30 metres
Crucifixion scene carved on a disk-headed
cross.

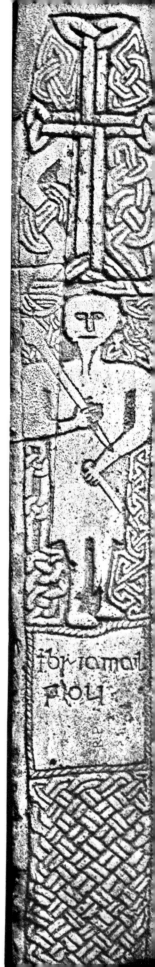

The monuments can be divided into two broad physical types—unhewn and sculptured. The unhewn stones, often apparently chosen for their natural regularity, may bear inscriptions (Group I of Nash-Williams) or sacred symbols (Group II), occasionally both. Their ancestry lies probably in the standing stones of the Bronze Age, but more immediately and obviously in the gravestones and milestones of the Roman period. The stones of Group I (about 140 in number) certainly belonged to the two centuries immediately following the Roman occupation, when Roman traditions were not entirely forgotten. The wording of epitaphs was influenced by practices current in Gaul and the Mediterranean area and to some extent by Celtic custom.

The Latin might be written horizontally to the viewer, in the Roman fashion, or it might be written vertically from top to bottom. In either case there was usually some attempt to start the lines at a constant left-hand margin, but they usually remained *unjustified* on the right—to use a modern printer's term. Very rarely did an inscription have a border. These inscriptions are interesting for their content, but only occasionally can one accord them the admiration reserved for Roman official lettering.

The stones of Group II (numbering over 150) are natural pillar stones or slabs, often very irregular in shape. The incised cross symbols which they bear are not so easily dated as inscriptions; many belong to the period from the seventh to the ninth centuries, but some are probably later.

The masons sometimes displayed heraldic sense in setting out their design to fill the space available, but the execution was often crude.

The use of stone tombstones bearing Christian inscriptions and symbols was a general feature of early Christendom, though not necessarily for everyone. In Wales the families of the deceased thus commemorated must have possessed a certain status and the means to commission the monument. The excavation of Early Christian cemeteries has revealed many graves not distinguished by stone monuments; they may have had wooden markers, which have since vanished.

The second main physical type of monument comprises those which have been sculptured in the round as free-standing monuments, or at least carved in relief on a shaped slab (Groups III and IV of Nash-Williams). The sculptured monuments are later in date than the unhewn. It was during the ninth century that the mason began to impose his own will on his stone, no longer allowing his creation to be confined (or dwarfed) by his raw material. The geographical distribution of the 125 examples in Group III indicates that patronage must have depended largely on Celtic ecclesiastical centres. It is possible that the new style was the result of trained craftsmen arriving in Wales from elsewhere. The free-standing carved crosses are found not only in Wales, but in Ireland, the Isle of Man, north Britain and England, and they appear to have been a distinctively British contribution to the art of the period.

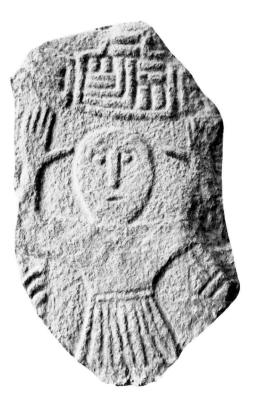

89 The Cefn Hirfynydd Figure
9th-10th century
Height 28in
0.71 metres
Praying figure or 'orans' on a fragmentary slab from Cefn Hirfynydd, Seven Sisters, West Glamorgan.

8 The Briamail Flou Cross-slab
Late 10th century
Height over 90in
2.29 metres
In Llandyfaelog Fach Churchyard, Brecknock.
One of the few depictions of an individual on a monument, possibly a local prince.

The monuments of Group III range over the ninth, tenth and eleventh centuries. They vary greatly in size, composition and proportion. The three main components of a monument were the head, shaft and base. Some of the larger crosses were actually made in two or three sections. There was a general preference for some form of ring-cross on the head —as a solid disk, a cut-out wheel or a panelled cartwheel. Sometimes the head had projecting arms, or more appropriately 'ears'. Some crosses had well-defined shoulders and a broad shaft widening towards the base. Pedestals could be elaborate.

To complete the classification of the Early Christian monuments, Nash-Williams assigned 26 miscellaneous late examples to Group IV. These belonged to the eleventh, twelfth and thirteenth centuries and marked the transition to the medieval monuments of the Normans, who favoured recumbent slabs to mark their graves.

The elements of decoration (or 'the grammar of ornament') used on the Early Christian stone monuments of Wales can be listed under eight main headings, not including lettering or naturalistic representations.

1 The circle and its variants. These include concentric, tangential and intersecting circles, interrupted circles, semi-circles, chi-rho derivatives, rounded squares, round bosses and occasionally ovals and spirals. The circle is very common on monuments of Group II in its simplest forms, and on those of Group III in more complex patterns.

2 The cross and its variants. These include linear (ie single-line) crosses, outline crosses and three-dimensional crosses. The arms may be equal (as in the *Greek* cross), or one may be lengthened to make a stem (the *Latin* cross), or the arms may have feet or cross-bars. The cross also is frequent on the monuments of Groups II and III, often combined with the circle. In the case of chi-rho derivatives, the cross is combined with the circle.

3 Rectangles and trapezoids. These include squares and sub-rectangular shapes with rounded corners. It might be said that the Early Christian mason refused to be tyrannised by true right angles and really straight lines, and this attitude (or lack of skill) gives an individual quality to each monument.
Rectangular shapes were used to define panels intended to contain ornament or inscriptions, and not as decorative motifs in themselves: they are rarely found in Groups I and II.

4 Interlacing and overlapping patterns. These include plaits, basket-work and knots, and are found mostly on the monuments of Group III. They may well have reflected patterns seen on everyday objects made of rushes, ropes and thonging, but they also have counterparts on Roman mosaics. Under this head fall the vine scroll and the Viking ring-chain pattern. Occasionally there were half-hearted attempts to terminate interlacing lines with animal heads, as in manuscript designs.

5 Interlocking patterns. These include key patterns, T-frets, maze designs and swastikas. These again are characteristic of the sculptured crosses of Group III, and often occur beside interlacing patterns in a balancing composition; their inspiration derives undoubtedly from Greek and Roman art, especially from mosaics.

6 Triangles and chevrons. These are ancient motifs, much favoured on pottery in Bronze-Age Wales. They include continuously-diminishing triangles on the principal of the spiral. Although sometimes resembling interlocking pattern, triangular ornament is usually constructed of independent units placed side by side; it, too, is often used in combination with interlocking and interlacing patterns, though it is perhaps not quite so common.

7 Twists. These usually resemble ropework, but are sometimes stylised into angular patterns. They are used for borders and to make interlacing patterns.

8 Columnar features. These simulate architectural detail, framing the design; they are not frequent. Only one monument is actually columnar shaped—the ninth-century pillar of Eliseg near Llangollen, Clwyd. This type was common in northern England in the following two centuries.

90 **Early Christian Brooches from Wales**
Left to right—
a Bronze pin with square head. From Castle Martin, Dyfed.
Length 3.875in, 98mm
b Bronze pin with pair of involuted spirals. From Castle Martin, Dyfed.
Length 2.875in, 72mm
c Bronze ring-headed pin. From the Lesser Garth Cave, Radyr, South Glamorgan.
Length 4.75in, 120mm
d Bronze penannular brooch. From shell-mounted at Linney Burrows, Dyfed.
Length 1.625in, 42mm
e Silver penannular brooch. with admixture of copper. From settlement site at Pant-y-saer, Anglesey. Date 7th century.
Length 4.75in, 110mm
f Part of bronze 'thistle' brooch of Irish type. From Culver Hole, Gower.
Maximum diameter 3.5in 88mm

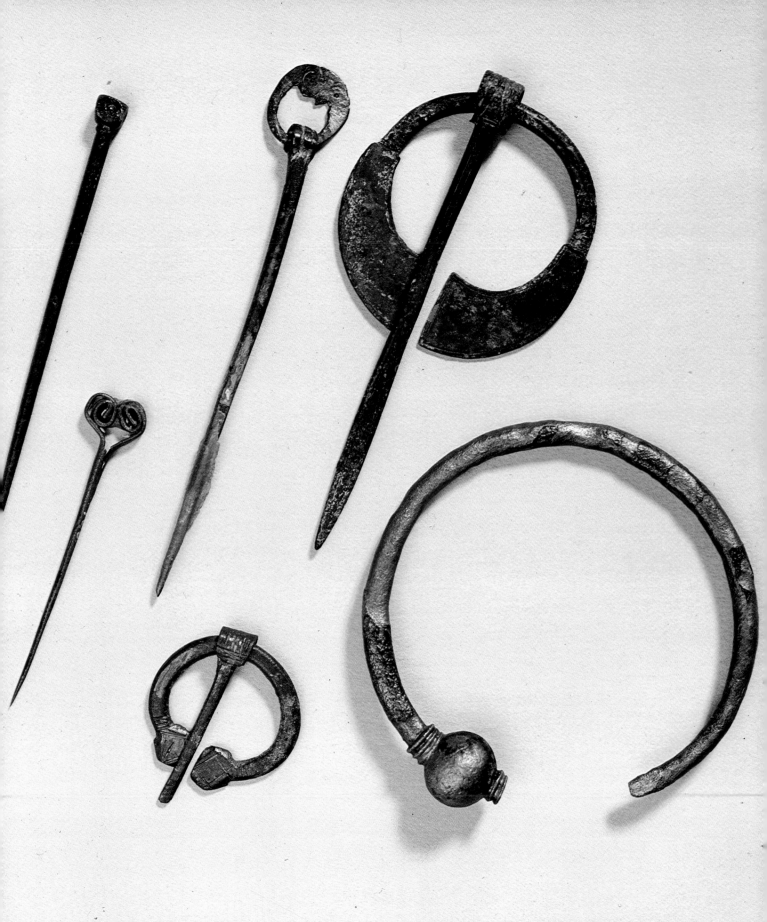

Much of the decoration bears a superficial resemblance to the Celtic art of the Early Iron Age, but close examination discloses much more angularity in the Early Christian work; there was little use of the free-flowing curve with vacant interspaces or creative voids.

Of all the stone monuments, the sculptured, free-standing crosses of Group III are artistically the most interesting. They are often majestic and beautiful, displaying balance in composition and skill in execution. A half-dozen or so stand out as masterpieces—the crosses of Penally, Carew and Nevern in Dyfed (Nash-Williams 364, 303, 360), Maesmynis in Brecknock (N-W65), Llantwit Major in South Glamorgan (N-W220), Coity in Mid Glamorgan (N-W194) and Penmon in Anglesey (N-W 37, 38). A rather different monument of the same group is also worthy of mention: the monument of Briamail at Llandyfaelog Fach, Brecknock, a coffin-shaped slab carved on one side with geometric ornament and a vigorous bearded figure carrying a dagger and a sceptre; perhaps he was a secular ruler (N-W49).

Comparatively few of the Welsh monuments bear representations of divine, human or naturalistic scenes; where they do, the workmanship is usually clumsy. Sometimes the work has an endearing primitive quality; occasionally it shows an economy of line which would do credit to a modern cartoonist.

There are a few crucifixion scenes, various anonymous portraits, perhaps scriptural, ecclesiastical or even secular, and several examples of praying figures with upstretched hands. Some problematic animals are represented on a few monuments.

The lack of achievement in Wales contrasts markedly with the wealth of figure-representation on similar monuments elsewhere, especially in Ireland and Pictland. In Ireland there are numerous carvings of primitive style in low relief, showing scenes such as *Daniel in the Lions' Den* or the *Flight into Egypt*. Although scriptural in origin, these episodes were immediately inspired by church liturgies, which also found expression on portable works of art. The Pictish stones of Scotland exhibit a remarkable duality, bearing in many cases a Celtic treatment on one face and a quite dissimilar composition of Pictish symbols and vigorous human and animal figures on the other.

It is curious how this figurative art by-passed Wales. It is sometimes said that Wales was culturally isolated and in-turning in its attitude. This was true on its eastern border, as a result of the creation of Offa's Dyke by the Mercians at the end of the eighth century. But as far as the western coasts are concerned, archaeologists are continually emphasising the cultural links across the Irish Sea.

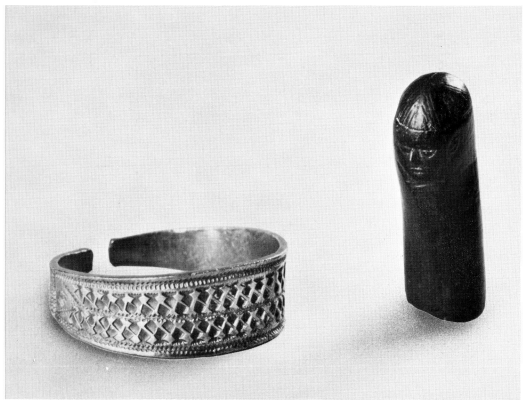

91 Early Christian Objects from Wales
a Silver Viking armlet, one of five found in Dinorben quarry, Anglesey, Gwynedd. Date 9th-10th century.
Maximum diameter 2.75in 70mm
b Basalt whetstone carved in form of girl's head (with pigtail at back). Found between Colwyn Bay and Llandudno Junction, Gwynedd. Date 7th-9th century.
Height 2.75in, 70mm

92 The Gospels of St Chad
A decorated page from the Gospels of St Chad, showing the evangelist Luke (page 218 of manuscript).

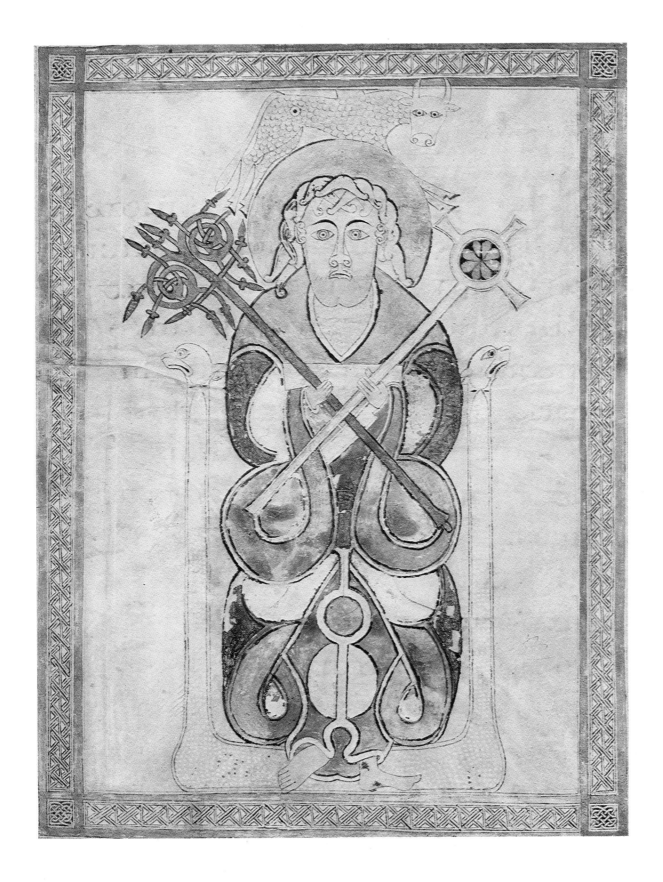

unum uni cuice secundum opera sua
& profectus est satim abiit tutem qui
quinque talenta acceperat & operatus
est in eis & lucratus est alia duo qui
quinque similiter & qui duo acceperat
lucratus est alia duo qui autem unum
acceperat habens fodit in terram & ab
scondit pecuniam dni sui post mul
tum uero temporis uenit dns seruo
rum illorum & possuit rationem cu
eis & accedens qui quinque talenta
acceperat obtulit alia quinque tal
lenta dicens quinque talenta mihi tra
didisti ecce alia quinque super lucra
tus sum ait illi dns eius euge serue bo
ne & fidelis quia super pauca fuisti
fidelis super multa constituam in tra
in gaudium dni tui accessit alter & qui
duo talenta acceperat & ait duo ta
lenta tradidisti mihi ecce alia duo lu

The portable objects which have come to light in Wales are extremely plain. There are bronze and iron bells of uncertain date, usually presumed to be for religious use, though some could hardly have been simpler if intended for cattle or sheep.

Various types of pin and brooch served as fasteners for cloaks. Some characteristic Dark-Age types have been found in Wales, but nothing to approach the best of the Irish material for richness of decoration and craftsmanship. A glimmer of Celtic tradition can be seen in the pair of facing spirals on a pin from Castle Martin, Dyfed, but this cannot be said of the crude angular decoration on the brooch from Linney Burrows, not far away.

Portable religious objects of metal, such as reliquaries, book covers and croziers were used during the period, but none has survived in Wales. Part of a basalt whetstone of Dark-Age date was found between Colwyn Bay and Llandudno Junction; it bears an attractive carving showing the head of a girl with a pigtail falling behind. A hoard of five Viking armlets of silver was discovered in Dinorben quarry in Anglesey; they are attractive objects but represent an isolated and intrusive feature in the artistic record.

The dearth of illuminated manuscripts with Welsh associations has already been mentioned. This is not the place to discuss the interesting, though scanty, secular texts which have survived by recopying, such as the historical works of Gildas and Nennius. It was the religious manuscripts which received artistic attention, in particular the texts of the Gospels. Many must have been in use in Wales, since otherwise Christianity would not have survived.

One manuscript book of the first importance has undeniable associations with Wales, the Book of St Chad, now at Lichfield Cathedral. Scholars are divided in their opinions on its date, origin and early history. It belongs stylistically to a series of books containing the four Gospels, all of which originated in, or derived their inspiration from the monasteries of Ireland between the sixth and ninth century. Such books were not for public reading nor for private study. They were holy possessions of a particular church, kept in a prominent but safe place near the altar as visible evidence of the importance of that foundation and of the authority of the church in general. Thus was the injunction of Exodus XXV, 16, obeyed: *and thou shalt put into the ark the testimony which I shall give thee*. It may seem strange that all the beauty of the Book of Kells and the Book of Lindisfarne—to give two outstanding examples—was probably seen only by the scribes themselves and a few church dignitaries.

The Gospels of St Chad were so named after the Patron Saint of Lichfield (who died in AD 672), and they were certainly in the possession of Lichfield Cathedral by the late tenth century. The main text is written in Latin in an exquisite half-uncial script, but part is missing, including the last page where the colophon would have given some of the history of the document. Its interest from the Welsh point of view is that it contains in a margin the earliest known piece of written Welsh, as well as some Latin incorporating early Welsh names. These marginal memoranda may be themselves copies of earlier documents. From this evidence it is clear that the Book must have spent a long period in Wales in the early part of its existence. Some scholars have believed that the locality was Llandaff, on the grounds that one marginal note declares the Book to be the property of the Church of Teilo, and Llandaff was, at any rate latterly, associated with that saint's name. Recent research, however, makes it seem much more likely that the locality concerned was Llandeilo Fawr in the north of Ystrad Tywi. It is further suggested that the Book found its way to England in the early tenth century as a gift (possibly in AD 934) from King Hywel Dda to King Athelstan of Wessex and Mercia, who thereupon passed it to the Bishop of Lichfield. It is still, however, impossible to say where the actual writing and illumination was done.

Many of the decorative motifs found on the stone monuments and portable objects occur also in manuscript decoration. But the scribe had opportunities for fine work with quill pen and brushes on vellum which were not open to the monumental mason. There is the same predilection for interlacing, interlocking and twisting patterns, but in the manuscripts they often take on grotesque animal shapes, especially at their terminals. By contrast, divine and human images tend to be transformed into geometric shapes.

Any attempt to assess the artistic heritage of Early Christian Wales is bound to be incomplete, and may at present be premature. Archaeological investigation of the period has made considerable progress in the last few decades, and much more evidence may emerge before long. The existing material is full of interest: some of it may be artistically naive or clumsy, but there are masterpieces of high quality. The art of this period represents partly a resurgence of prehistoric Celtic tradition and partly the legacy of late classical art. Both were amalgamated into a new style having its own identity and distinctive genius.

Donald Moore

93 A Page of Text from the Gospels of St Chad, (page 117 of manuscript)

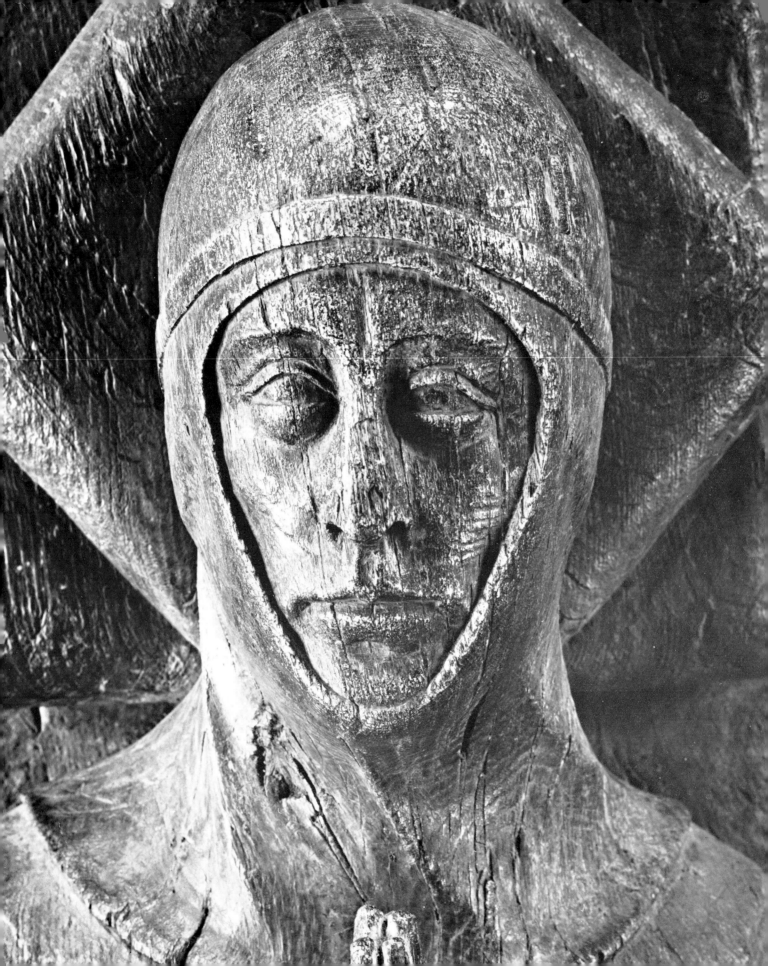

the medieval period

At many points in their history the land of Wales and its people have found themselves caught up in a cultural unity with other Celtic countries bound together by the western sea-routes that run from Brittany to the Hebrides. Thus it was during the centuries between the departure of the Romans and the coming of the Normans. Though not entirely cut off from cultural and other contacts with England and the Continent, Wales was largely turned in on herself and her Celtic neighbours. The result was not necessarily stagnation or decline. The Dark *Ages* are dark not because they were unillumined by civilizing influences but because repeated attack and devastation by barbarian raiding destroyed so much of the materials from which their history might be constructed. When the Normans came to England and Wales they themselves may not have brought a vastly superior civilisation with them, yet they helped to end the phase of negative destruction by Norsemen. They also provided bridgeheads on the wider shores of European culture and threw open the routes for an invigorating two-way traffic between Europe and the Celtic west. Thrustful Norman adventurers, within two generations after 1070, had penetrated deep into Wales along the river valleys that wind upward into the hills from the English border. They ousted Welsh rulers, arrogated to themselves their sovereign rights and created many a powerful quasi-autonomous marcher lordship. There they began to build their castles and to plant their boroughs. In their wake came monks and priests bringing to the Celtic Church of Wales the rites, law and organisation of Rome. The Normans' threat to overrun all Wales evoked a powerful Welsh response. Statesman and warrior, prince and prelate, lawyer and bard; all fought to retain a part, at least, of Welsh independence. For two centuries they held marcher lord and English king at bay; but at last in 1282-3 Edward I proved too strong for them, and Owain Glyn Dŵr's Rebellion, 1400-15, despite all its bright hopes fo the future, proved to be no more than the post-mortem spasm of an old Wales that was dead but would not even yet lie down. Yet Welsh and Norman, Latin and Celt, had commingled as well as clashed. Culturally and artistically each had rubbed off much on the other. Welsh Wales and Norman Wales were a part of one another and of the Europe of the Middle Ages.

Detail of illustration 94

Detail of illustration 111

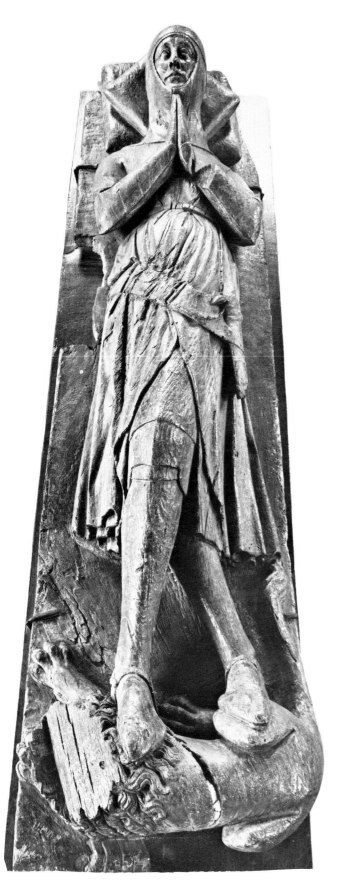

Medieval Europe had shown the stirrings of its vigorous new phase in the history of civilisation from the eleventh century. Barbarian onslaughts were everywhere staved off, contained, or absorbed; and European life could emerge again from the redoubt into which it had been forced to retreat. Trading arteries, long clogged, began to pulsate with the healthier flow of the lifeblood of commerce. Population grew, new lands were cultivated and towns flourished. Stable government by reinvigorated monarchies began to curb the worst excesses of feudal particularism and anarchy. Learning and the arts gained new heart and confidence. The features of medieval civilisation took shape and definition, and for three or four centuries they prospered prodigiously. Among the triumphs of the human spirit the medieval achievement merits a high place. It was the product of two powerful institutions: the landowning aristocracy and the Church. Understandably, its most typical symbols are the castle and the cathedral.

Turbulent, brutal and crass as the laity could often be, theirs was none the less a robust and constructive contribution to medieval civilisation. Their castles, though severely functional in purpose and design, were often things of beauty as well as manifestations of power. It is almost impossible to believe that the men who built the castles at Kidwelly, Carreg Cennen, or Caernarvon, who carved the capitals at Castell y Bere, had no sense of the aesthetic

94 **Effigy of a Knight**
 Late 13th century
 Oak, Length 72in
 183 cm
 One of the hands is missing, and there was a shield attached to the figure in all probability. Traces of paint remain; the surcoat strap and sword belt show traces of gilding, and the spurs were gilded according to Symonds writing in 1645 (Diary of the Marchings of the Royal Army). The crossed legs resting on a lion signify the knight died 'for his magnanimity'. The identity of the figure is not completely certain, but it is probably Geoffrey de Cantelupe, 1253-1272, on the evidence of his youthful features. Of English workmanship.

fitness of design and appearance and were concerned only with erecting effective barracks. More peaceful and more modest domestic architecture, such as that represented by Hendre'r-Ywydd at St Fagan's, tells the same story. The more influential landowners, Welsh and Norman alike, aspired to leave symbols of their status in death no less than in life. Some of the most powerful surviving medieval works of art are the sepulchral effigies and slabs carved to perpetuate their memory, and Bishop Anian ab Ynyr of St Asaph (d 1293), himself a scion of princes, may have left at St Asaph an effigy as proud and eloquent as the superb memorial slab to Madog ap Gruffudd (1306) at Valle Crucis or Geoffrey de Cantelupe's effigy (1272) at Abergavenny. Nor were laymen's ears less sensitive than their eyes. The Homeric tradition of Welsh verse was already centuries old when the Middle Ages were in their infancy. During the medieval period it developed a new range and flexibility. Poets sang to the Welsh *uchelwyr* who were their patrons with gaiety and full-blooded acceptance of all the joys of medieval man's existence—of battle and war, love and nature, food and drink, hunting and hawking and exquisite craftsmanship in many materials. In the prose romances the peculiar conjuncture of Welsh and Norman gave to Europe in the Arthurian tales one of its most fecund and enduring artistic motifs. To preserve these and other treasures, manuscripts were long and laboriously copied and often became themselves a delight to the eye.

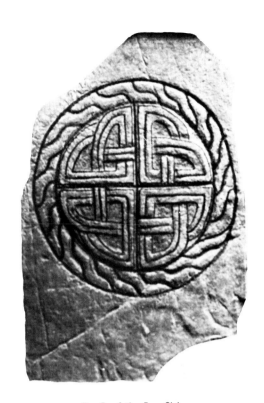

96 Pen Arthur Farm Slab
9th-10th century
Height of slab 21in
0.54 metres
Ornamental ring-cross on slab
From Pen Arthur Farm, St David's, Dyfed.

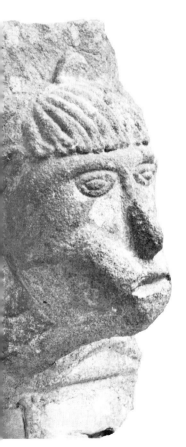

95 Carved Stone-work
Early 13th century
a Capital of a corbel shaft with stylised floral
detail
Height 13in
33cm
b Corbel stone with carved human head, the
lower half restored
Height 13in
34cm
From the site of Castell y Bere (Gwynedd),
a castle built by Llywelyn the Great to
control the southern part of his territory,
and destroyed by the Welsh in 1295.
Col J F Williams-Wynne, D S O and the
National Museum of Wales

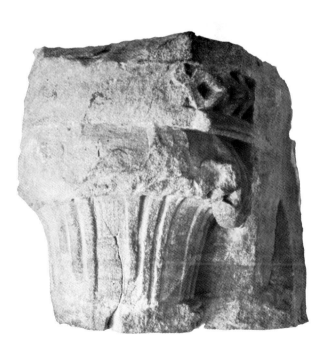

97 Jesse Window

The east window of the parish church of Llanrhaeadr Dyffryn Clwyd, it was put up in 1533. It depicts a favourite medieval theme, the Tree of Jesse, showing the descent of Christ from King David, and contains the most beautiful surviving medieval stained glass in North Wales.

98 Caernarvon Book of Hours

14th century

6.875 x 4.75in

17.5 x 12cm

A Book of Hours associated with Caernarvon by virtue of the local saints represented in the Calendar. There are seven full page miniatures: the Annunciation, the Virgin, St Peter and the Emperor Maximus (?) the Macsen Wledig of Welsh legend, a Bishop, the Virgin and Child, and the Trinity. Written in Latin.

Enriched by the spread of trade and growing production medieval Europe achieved a relatively luxurious standard of existence—for its upper classes at least. Among the wealthier men in town and country, life became markedly less bare and unadorned. High standards of delicate craftsmanship were achieved in cloth, wood, stone, metal and paint. Hardly any of the objects then made have come down to us, but we can gauge from the Welsh begging poems, the *cywyddau gofyn*, of the 14th and 15th centuries in which the poets describe with loving detail the objects coveted by their patrons, how much store was set on aesthetic values.

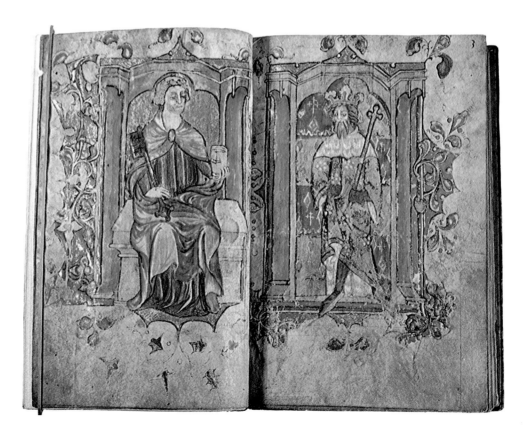

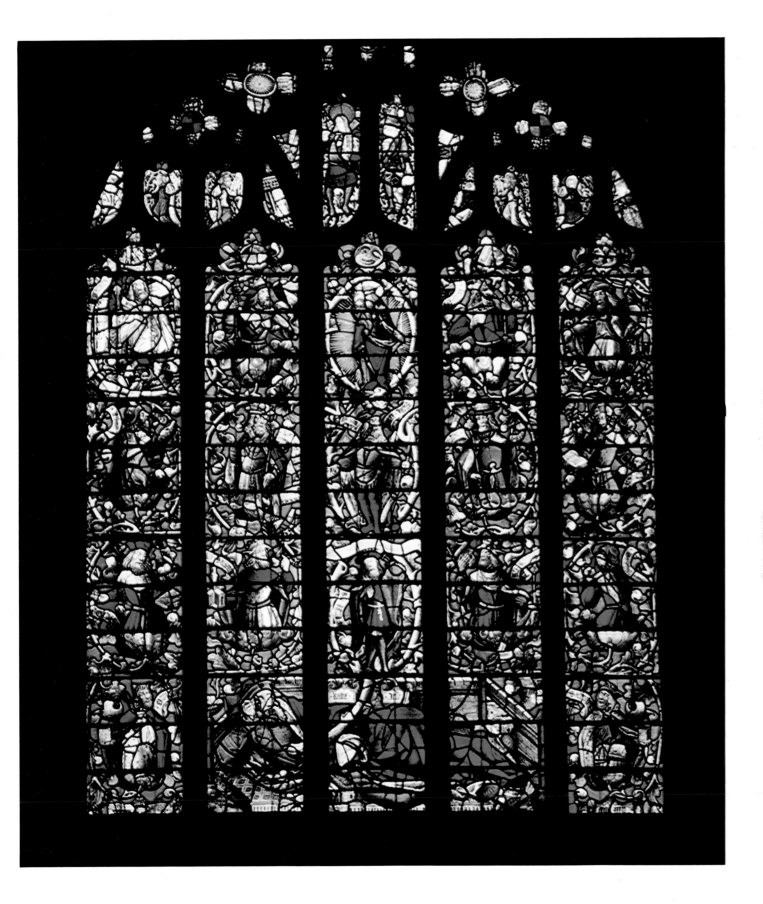

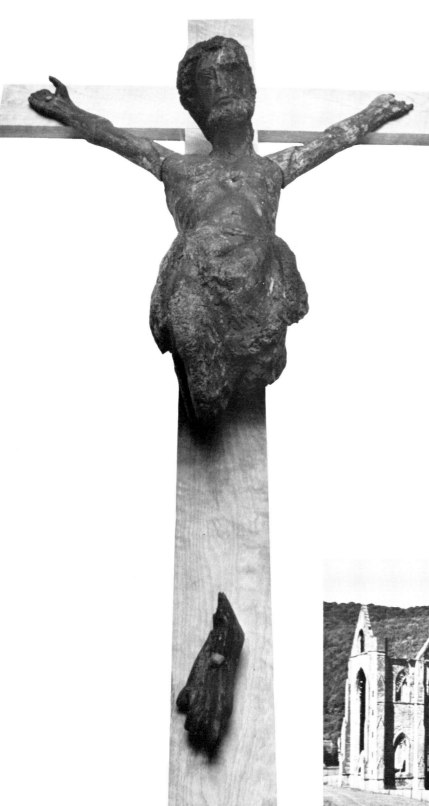

99 Rood figure of Christ
14th century
Wood height of figure 48in
122cm
Found about the middle of the 19th century in a blocked-up staircase in the church at Kemeys Inferior (Gwent), and thought to have stood originally on the rood loft. Wooden crucifix image with traces of the original paintwork. One of few figures to have survived the iconoclasm of the 16th century.

100 Tintern Abbey
The largest of the Cistercian abbeys in Wales, Tintern was founded in 1131 as a daughter house of the abbey of L'Aumone in Normandy. Almost completely rebuilt in the thirteenth century, it represents the finest achievement of Cistercian architecture in Wales. After it was dissolved in 1536 the site and much of the estates passed to the Earls of Worcester.

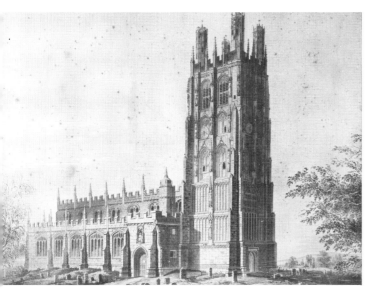

01 Wrexham Church Tower

This perpendicular tower, with its striking
crocketed pinnacles, is one of the largest
and most handsome church towers in Wales.
It was largely built in the reign of Henry VII,
though it may not have been completed until
c 1518. It was traditionally included among
the 'seven wonders' of old Wales.

However, the great matrix of art and learning in the Middle
Ages was the Church. Much of the achievement stimulated
by her patronage can still be seen and enjoyed *in situ,* and
by far the most numerous and widespread of the monuments
of the Middle Ages are our ancient churches. Although in
the 19th century many of them were unimaginatively
restored and many of their medieval treasures swept out
like so much useless lumber, enough has survived to give us
our most revealing insights into the heart, the mind and the
spirit of the Middle Ages. None of our Welsh churches, with
the exception of one or two of the biggest Cistercian
monasteries, was large by English or Continental standards.
But what they lacked in size they made up for in the beauty
of their surroundings and the unpretentious fitness of their
architecture and building materials. St David's or Tintern
need fear comparison with few churches. Gresford shows
what an architectural gem, superbly furnished and adorned,
could be fashioned in a parish that was far from populous or
wealthy. The modest little church at Llanrhaeadr Dyffryn
Clwyd has a superb *Jesse window,* unquestionably the finest
surviving exemplar of all those artistically-depicted sermons
and stories in stained glass that once edified and delighted
pious illiterates in many Welsh parish churches. Admittedly,
elaborate work in stone, usually found in rich, low-lying
agricultural country and teeming market-towns, is relatively
rare in Wales. Yet handsome crocketed and pinnacled
towers stand in more than one Welsh town from Wrexham's
—one of the seven wonders of old Wales—all the way down
the border to St John's, still the most elegant landmark in
Cardiff's townscape. Some of the monasteries, too, though
remote from towns, lacked neither daring nor dignity in their
architecture; whether it be the soaring grace of Llanthony's
nave or Valle Crucis's superb rose window. As for Bishop
Gower's episcopal palace at St David's, it can surely have
had no peer in medieval Wales for symmetry, proportion
and unaffected ornament.

**102 Bishop's Palace,
St David's
14th century**

The arcading shown is an unusual feature in
British architecture, being an adaptation of
North Italian Romanesque, with its
veneering of coloured stones of purple,
cream and white, arranged in a chequer-
work pattern.

103 Part of Conway Church Screen
Late 15th century
The whole screen measures
25.5 x 13 ft high
6.8 x 4 metres

The carvings along the top beam (or bressummer) are shown. Various Tudor devices appear eg rose, dragon, falcon and running greyhound; the three feathers are for Arthur, Prince of Wales, and the gull's leg grasping a fish is for Sir Richard Pole.

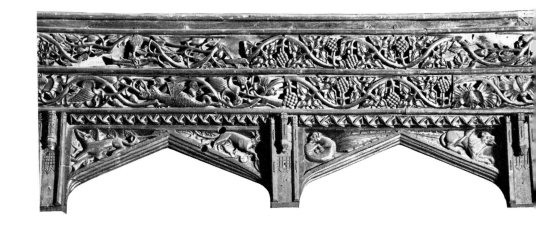

104 Sleeping Jesse
late 14th-early 15th century
Oak, Length 120in
305 cm

Originally part of a Tree of Jesse. The right arm is broken. The figure is hollowed out behind. Traces of paint remain (red on cap and pillow, green on branches). A small cavity at the bottom of the beard may have been for relics. Originally this Tree of Jesse may have been a reredos. The earliest mention of the figure is by Church-yard in 1586 (Worthines of Wales) when it is described as 'defaced, and pulled down in pieces'. In 1645 Symonds (Diary of the Marchings of the Royal Army), described it as once 'a branch did spring from him, and on the boughs divers statues, now spoyled'. The subject derives from Isaiah 11, 1-10. Iconographically the design was probably first used by the Abbe Suger in the 12th century. It came to England in the 13th century; after a hundred years it was commonly found in British psalters, embroideries, windows and in some carvings (eg at Christchurch, Hants, Llantwit Major and St David's). The attraction of the theme was the association of Christ with a long royal lineage, thus incorporating him into the brotherhood of feudal nobility. There appear to be traces of Flemish inspiration in this figure.

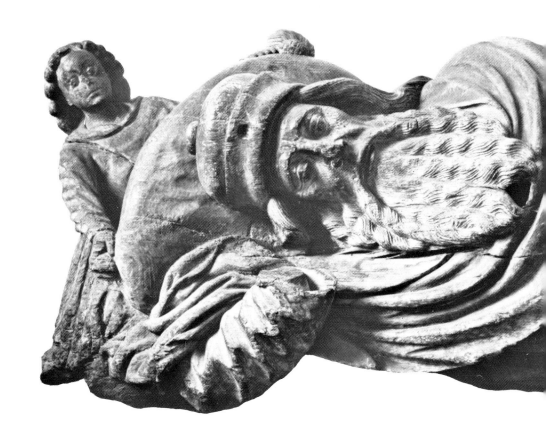

Good as it can often be, however, the art of the medieval mason in Wales has in general less merit or individuality than that of the woodcarver. In Wales timber was in much better supply than good building stone and the woodcarver's art was universally found and highly esteemed. The carpenters were ranked by the poets alongside themselves, as artists, which says much for the formers' mastery of their medium. Close affinities of standards and inspiration can be discerned between the two art forms. In both the artist was content to allow himself, both by the canons of his craft and the requirements of his patrons, to be confined to a limited number of highly stylised themes and patterns. In wood and word the flowing vitality and exuberance of the artist were enhanced rather than fettered by his strict adherence to the meticulous detail and the exacting strict classicism of his artistic conventions. The vines, the wyverns and the traceries so lovingly fashioned in a Welsh roodloft

or roodscreen could be as congenial an expression of Welsh medieval aesthetics as the poet's *cywydd* or *englyn*. Nor was woodcarving confined to abstract patterns; it extended also to the fashioning of human figures. The pieces from Abergavenny Priory or the Kemeys Christ show the disciplined control and moving power of such representation. But to experience the full impact of what the woodcarvers could add to medieval art and worship, their screens and lofts, the crowning glory of many Welsh medieval churches, must be sought out where they still survive in small country churches off the beaten track, in places like out-of-the-way Llaneilian in Anglesey or even remoter Patricio in the folds of the Black Mountains. Their roofs, too, still overhang the worshipper—or the merely curious—in many a church, from that supreme masterpiece of Irish bog oak in St David's to Llangollen's rich and sturdy canopy.

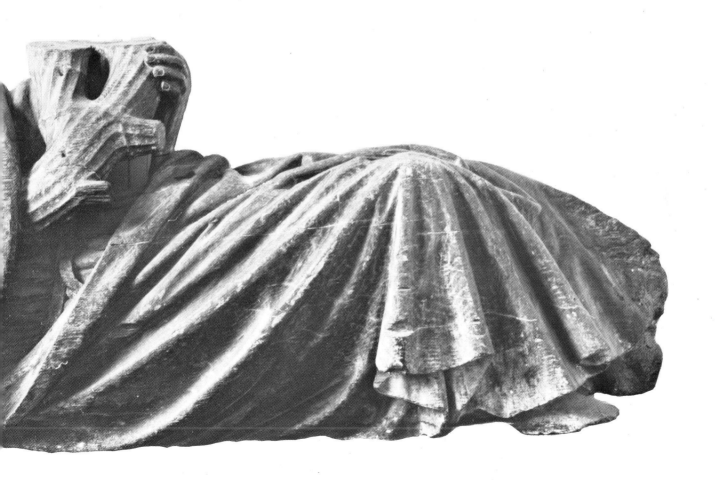

105 St David's Chalice
c 1280
Silver 5in high
12.7cm
The joint between the base of the knop and
the stem has been repaired. Found in the
grave of Richard de Carew, Bishop,
1256-1280.

106 St David's Cathedral Roof
Late 15th century
There is no known parallel for this roof,
which was built as a replacement for the
high pitched original roof between 1495
and 1508. The architects were faced with
the problem of deflecting walls and devised
the existing roof around the much needed
tie beams, which give it the distinctive
flatness. Made of Irish bog oak.

Much of the medieval woodwork was coloured by the painter's brush; and the poet, Siôn Cent, tells us of painters *painting a host of images in the colours of the stars*. Painters were everywhere greatly in demand in medieval Welsh churches; some to gild and decorate the woodwork, others painting frescoes like those which have come down to us at Rhiwabon or Llantwit Major and still others painting wooden panels like those in the canopy of honour at Gyffin or Llanelian yn Rhos. Some of the paintings may just possibly have been important works of art. It is true that the splendid triptych by Hans Memlinc for so long thought to have been commissioned by Sir John Donne of Kidwelly is now known not to have been painted for him, yet it is certainly not out of the question that some Welsh clerics and laymen bought the works of leading artists. A fifteenth century painting of the Assumption, once part of Bishop Marshall's throne, is still preserved in Llandaff's Lady Chapel. And was it perhaps the compulsion of a great painter's art which made the men of Maelienydd so desperately anxious to solicit the government's permission to retain a picture of Jesus that had once been in Cwm-hir Abbey and was moved to Strata Florida when the little Radnorshire house was dissolved?

Not enough of the paintings of Welsh provenance survive to enable us to answer such questions with any confidence. But some of the church plate which has come down, like the St David's chalice or the chalice and paten found near Dolgellau, and now in the National Museum of Wales, shows us how Welshmen knew and appreciated fine examples of the jeweller's art when they saw them. Later church plate from the 16th and 17th centuries, such as the Communion Cup from Carmarthen, suggests that in this respect, at least, much that was exquisite in medieval taste survived long after the Reformation period.

108 Communion Cup
c 1574
Silver 7.25 high
18.4cm

Engraved with strap and leaf design and inscribed Poculum Ecclesie de Llanvychangel Estrad. Probably a Carmarthen goldsmith; 73 cups survive from this workshop and are mostly to be found in the archdeaconries of Cardigan, Carmarthen and Pembroke.

Female Effigy
Mid 16th century
Oak Length 73in
185cm

The face and the middle portion of the arms are mutilated. The only surviving figure from six (three husbands, three wives) which comprised the Games monument at Brecon. There were three tiers of oaken beds which must have been 10 to 12 feet high in all. Churchyard, in 1587 wrote of it: Three couple lies one ore the others head/Along in tombe and all one race and lyne . . . These are indeed the ancient race of Gams. Symonds saw the tomb in 1645. In *c* 1685 Thomas Dinely related the sad destruction of five of these figures; in the chancel, he wrote, is seen a wooden monument with as wooden Tymes about it in old English character, there is but one large figure left Thereon the rest was sayd to be burned by ye usurpers souldiers, it belonged to a good Family of Game's of Aberbrain. The identity of the figure is uncertain; it could be Elinor or Anne Games. Probably of English workmanship.

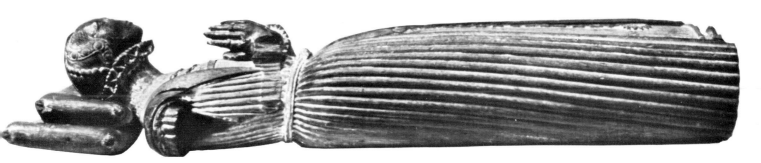

**109 Watercolour copy of a Fresco
detail showing St Christopher
Early 16th century
Height c 96in
244cm**

The original is still visible on the north wall
of the nave at Llantwit Major Church. St
Christopher was a very common subject
in British mural painting, for it was generally
believed that whoever beheld his image
would be invigorated in his faith.

110 Raglan Castle

Building was begun in the fifteenth century
by Sir William ap Thomas (d. *c* 1445) and his
son, William, 1st Earl of Pembroke (d 1469).
It was greatly extended and beautified in
Renaissance styles by the Earls of Worcester,
notably William, 3rd Earl (d 1589) and Edward,
4th Earl (d 1628). In the Civil Wars it was one
of the main Royalist bases in Wales and the
west and endured a long and hard-fought
siege.

ven so, the Reformation marks the end of an era. The shift
f emphasis from participation in communal ceremonies
nd ritual to the inward apprehension of salvation by the
eliever and Protestant criticisms of the idolatry associated
vith external aids to worship, restricted if they did not
xtinguish ecclesiastical art. Along with such changes came
nother of equal importance—the rise to prominence of a
uling class of Renaissance gentry and wealthy merchants.
hey now assumed the role of leading patrons of the arts,
nce largely the monopoly of the clergy. A handful of the
ew landowners aspired to become the complete men
mbodied in the Renaissance ideal of the courtier; not just
oldiers and hunters, or magistrates and landlords, but also
ntellectuals and aesthetes of discerning tastes and refined
ensibilities. Their houses, now become more elegant,
pacious and comfortable, were adorned with more and
etter furnishings, rich woodcarving and graceful stonework,
andsome plate and glowing glass, gay tapestries and
xuberant frescoes, portraits and paintings by English and
oreign artists, libraries replete with books and manuscripts,
nd choice collections of armour, weapons, coins and
tatues. The earls of Worcester transformed Raglan Castle
rom a grim baronial stronghold into a palatial country
nansion, with brick-built gazebos and a series of statue-
niches, *a pleasant walk set forth with several figures of the
Roman Emperors in arches of diverse varieties of shell-works.*
At Margam, once the cradle of Celtic Christian art and
Cistercian austerity, the Mansels created what was described
by an admiring Thomas Dinely as a *very noble seat*, with its
*summer banqueting house built after the Italian, whose
regular symmetry, excellent sculpture, delicate graving and
an infinity of good Dutch and other paintings make a lustre
not to be imagined.*

From Tudor times onwards it is to the manor-house not the
monastery, the counting-house not the cathedral, that we
ook to find the men who gave—or neglected to give—the
artist his commission. For three centuries or more the history
of art is hardly more than a facet of the history of the gentry.

Glanmor Williams

111 Dolgellau Chalice and Paten
 c 1250 Electrotype copies
 a Chalice
 Gilt 7.25in high
 18.4cm
 Engraved under foot NICOL'VS ME FECIT
 DE HERFORDIE
 b Paten
 Gilt 7.25 diameter
 18.4cm
 Engraved with the symbols of the four
 evangelists in the spandrels, the
 Pantocrator in the centre. Found in 1890
 under some stones near Dolgellau. The
 originals belong to HM the Queen, and are
 deposited in the National Museum of Wales.

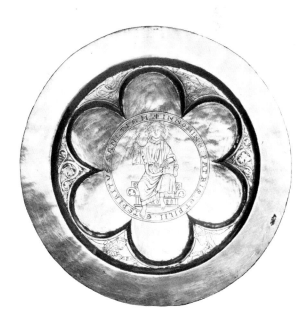

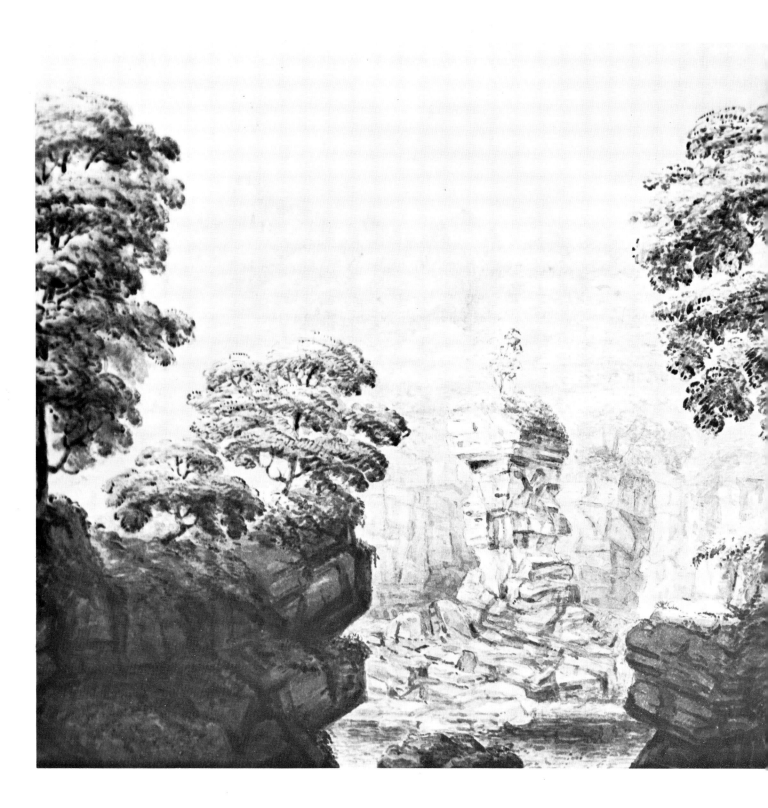

painting in wales
1550–1850

112 Moses Griffith
1747-1819
Pulpud Huw Llwyd o Gynfal
near Festiniog
Watercolour 11.125 x 15.125in
28 x 38.4cm
inscribed August 1806 in Merioneth

Detail of illustration 134

Within these three hundred years, which cover the period from the Acts of Union to the industrialisation of Wales, Welsh society was fundamentally divided between an agrarian community and an anglicised squirearchy. The sharpness of this division only increased within the period, and its effect on art in Wales, which is basically a question of patronage, was fundamental. Those people who had money enough to commission or to buy works of art were, almost without exception, of the anglicised community and their patronage was bestowed on English artists. The Welsh peasantry, committed to their labour, never afforded patronage, and developed instead a strong tradition of folk art which lies outside the defined scope of this survey.

Apart from economic difficulties a Welsh artist had also to face geographical isolation from the mainstream of European development. As long as the horse was the principal vehicle, travel in Wales was a hazardous undertaking. It was not until a thirst for emotional experience allowed the traveller to enjoy the risks involved that Wales became at all attractive as a tourist centre. When this happened, at the end of the eighteenth century, the influx of visitors was large, for in few other parts of Great Britain is nature so diverse or so terrifying. The final breakdown of this geographical barrier was only achieved with the advent of the railway, at the period this survey closes, in the mid-nineteenth century.

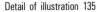

Detail of illustration 135

13 Thomas Hornor
 active 1816-1823
 The Rolling Mills at Dowlais
 Watercolour 11 x 18.75in
 27.9 x 47.6cm
 c 1816

114 William Roos
 1808-1878
 Christmas Evans
 1766-1838
 Canvas, oval 15 x 13in
 38 x 33cm
 Painted at Caernarvon in 1835. Christmas
 Evans was a celebrated Baptist minister,
 one of the most powerful of his day. He was
 blind in his right eye.

115 Anonymous
 1627
 Jenkyn Williams
 1548-c 1630
 Canvas 44 x 34in
 111 x 86cm
 Dated 1627. Jenkyn Williams was the first
 inhabitant of Aberpergwn House, Glyn, Neath.

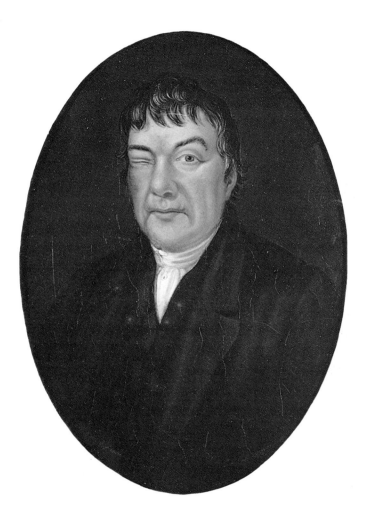

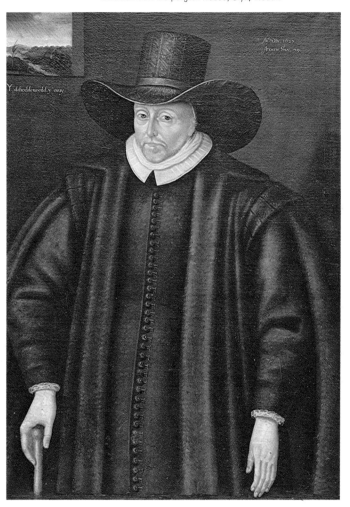

116 Richard Wilson
 1713/4-1782
 Valley of the Mawddach
 Canvas 35½ x 41½in
 90 x 105cm
 c 1770.

It is impossible to find indigenous paintings of quality in Wales between the sixteenth and eighteenth centuries. The canon of European art within that period was aristocratic, demanding a luxurious patronage; the Baroque and Rococo scarcely touched Wales and were known only through the imports of the squirearchy. Only rarely did these patrons lure an artist of standing into Wales, for it was generally easier and more economical to go in person to London.

The overall picture is modified in the nineteenth century with the changes wrought by the joint progress of industry and non-conformity, both of which fostered a new middle class, and encouraged an indigenous culture. The local portrait painter began to find his profession more respectable, and there are some few examples of middle-class patronage.

The paintings shown divide, therefore, into two quite separate groups, the works of Welsh artists, and the works of visiting artists. The first is distinguished by its provinciality, the second by its more cosmopolitan idiom. Without this distinction being clearly understood, this section can make little sense.

Welsh Artists
The earliest period of indigenous art is represented by portraits. They are conditionally of Welsh workmanship, according to their inscriptions or their style. Any comparison with the current London conventions of Holbein or van Dyck reveals the extent of their independence.

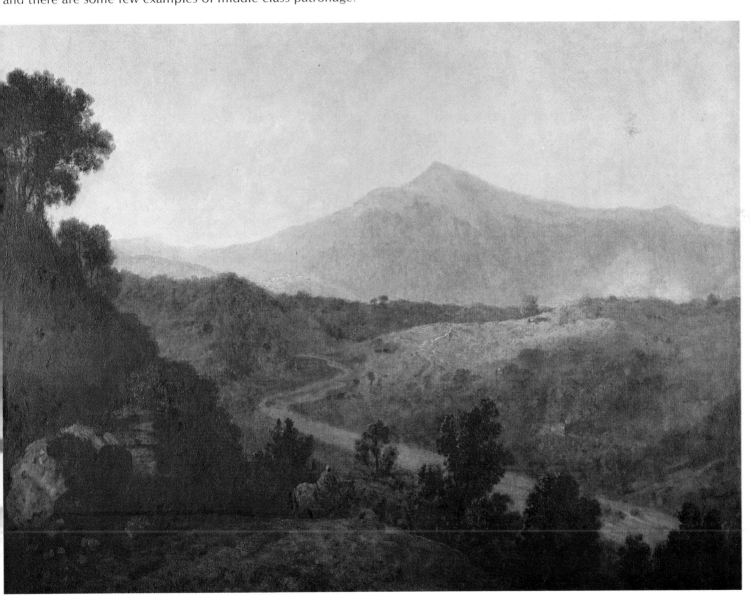

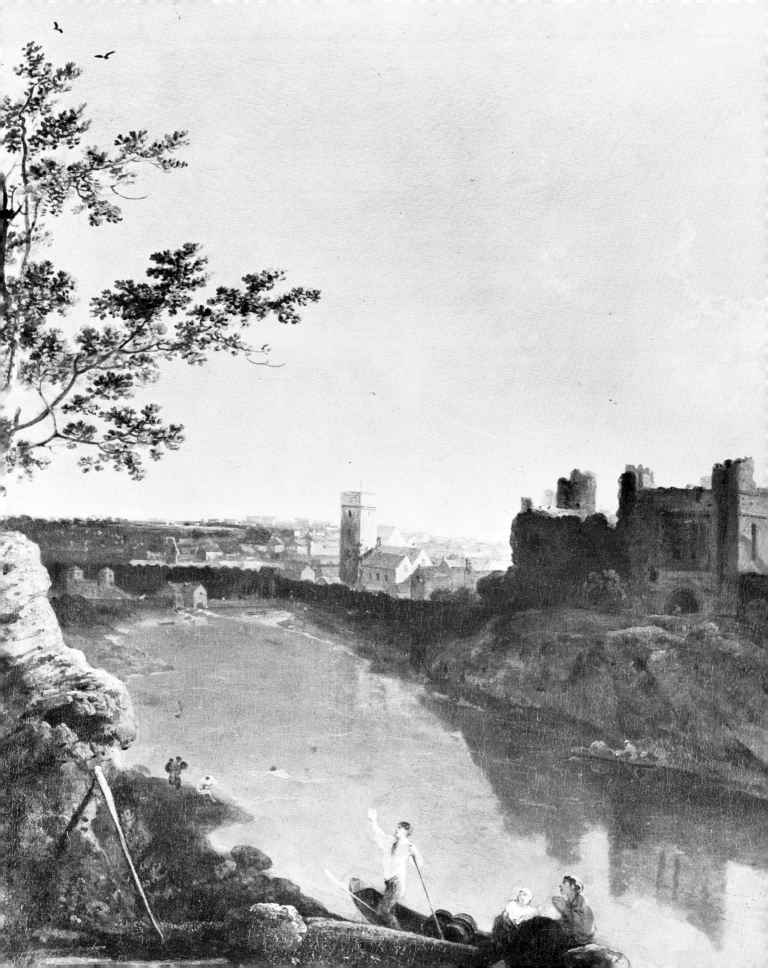

There is an increase in activity in the eighteenth century, suggested by a further selection of portraits, landscapes and topographical watercolours. Portraits show squires, industrialists, artists, harpists, Jacobites and gamekeepers, a stimulating contrast with the aristocratic traditions of portraiture elsewhere. There is less doubt concerning the Welshness of these pictures; there is evidence of landscape backgrounds and of biographies to help us, besides the obtrusive provinciality. The Welsh landscapes of Richard Wilson and of Thomas Jones considerably heighten the level of indigenous achievement. Both, while being Welsh by birth and inspiration, are of cosmopolitan making. They worked in London and travelled in Italy, and as a result of their considerable painting experience were able to appraise the Welsh landscape for the first time with an enthusiastic painter's eye. Wilson's Welsh landscapes need little publicity, but the fine open Radnorshire views by Thomas Jones are less well known, while being fully deserving of attention as pioneer excursions into the realm of naturalism. For both painters it would appear that landscape subjects were first inspired by the topography of their homeland.

The same could also be said for John Dyer, but unfortunately only a single watercolour survives to evince his activity as a landscapist. His name is well known to students of literature for his poetry in the manner of Thomson, his more famous contemporary. Dyer, like Wilson and Thomas Jones, studied painting, his first love, in London and later in Italy. Two of his other paintings, a portrait and a *Last Supper,* would suggest his verse was better.

Moses Griffith, *a good and faithful servant . . . tolerably skilled in music,* might typify the locally-trained artist in the eighteenth century. His master was the antiquary, Thomas Pennant, for whom he made over two thousand topographical drawings. He also essayed portraiture in oils. In the nineteenth century this tradition of local topography was continued by Hugh Hughes and Edward Pugh.

117 Richard Wilson
1713/4-1782
Pembroke Castle
Canvas 38.25 x 48.5in
97 x 123cm
c 1774. Engraved by Mason in 1775.

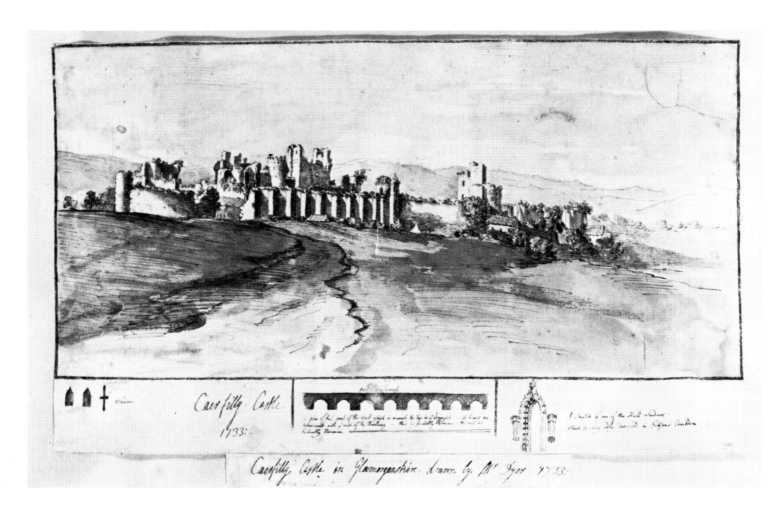

Caerffily Castle 1733:

Caerffily Castle in Glamorganshire drawn by Mr Dyer 1733.

The local portrait painter who emerged in the nineteenth century is exemplified in the works of W Jones, Roos and Thomas Brigstocke. Of these men Roos is alarmingly frank in his portraits of two thundering preachers, whose irrelevant physical blemishes are shamelessly underlined. Brigstocke's reputation was by no means confined to Wales; he visited the Middle East and Italy, and worked a long time in London. His *Self Portrait* shows a well judged balance between the factual and the dramatic, both in colour and pose.

Penry Williams, the last of the Welsh artists shown, has now a somewhat dulled reputation as a result of his repetitive views of the Roman Campagna, but before he left for Rome, in 1827, he produced the *View of Swansea* which is a competent and freshly observed landscape. His very early watercolours show the beginnings of a Welsh industrial landscape and evince the new patronage, since they were made for one of the daughters of the Crawshay family of industrialists.

Welsh Patronage

Of the specific patronage of local talent there is little to record. There is a curious and isolated example of a local sculptor, Richard Twrch (fl.1586) one of two brothers who owned a stone quarry at the mouth of the River Ogmore, being commissioned by Richard Bassett of Beaupre Castle to do the decorative stonework for his chapel—Pennant's use of Griffith has already been mentioned; Robert Taylor seems to have had a comprehensive commission from Welsh Jacobite societies. The nineteenth-century portrait painters have been mentioned, and there is in addition this minute from the Anglesey Hunt Balls' Committee dated 12 November 1830: *for the encouragement of Native Talent Mr Jones of Beaumaris be employed to paint the portraits of the Comptrollers in the uniform of the Hunt.* The result of Mr Jones' labours still survives at Beaumaris Town Hall.

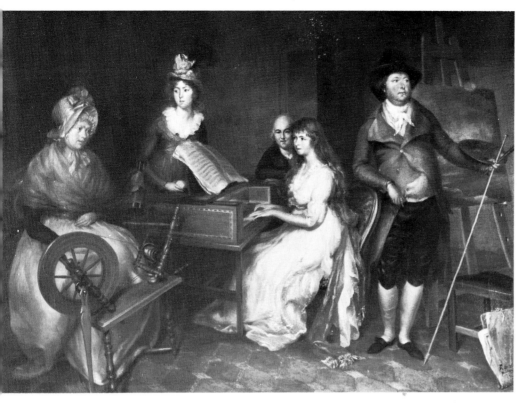

118 John Dyer
1699-1758
Caerphilly Castle
Watercolour 10.4 x 18.25in
26.3 x 46.6cm
1733. Additional smaller sketches appear
below the landscape with inscriptions,
apparently in the artist's hand.

119 Francesco Renaldi
active 1777-1798
Thomas Jones and his family
Canvas 29.25 x 40in
74.3 x 101.6cm
Signed and dated 1797. Inscribed verso:
Thomas Jones artist and sq(uire?) of
Pencerrig with his wife Rachel his two
daughters Mrs Thomas of Pencerrig and
Mrs Dale and Mr Dale(?).

120 Thomas Jones
1742-1803
The Bard
Canvas 45.5 x 66in
115.5 x 167.6cm
c 1774

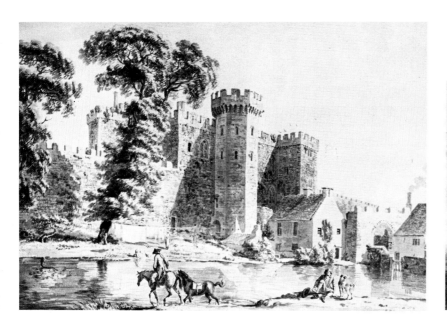

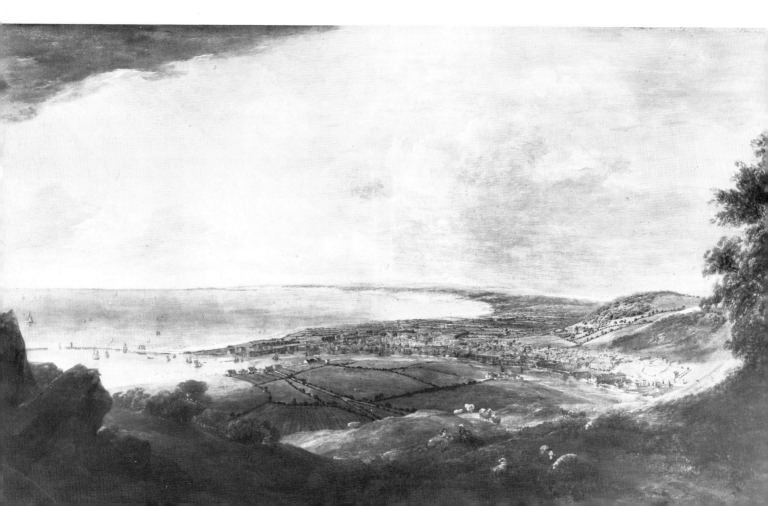

21 Paul Sandby
1725/6-1809
West Gate Cardiff
Watercolour 14.75 x 20.5in
37.4 x 52 cm
1773 Published as an aquatint in 1775

22 Thomas Jones
1742-1803
Pencerrig
Oil on paper 9 x 12in
22.9 x 30.5cm
c 1772

23 Thomas Brigstocke
1809-1881
Self Portrait
Canvas 29.5 x 25in
75 x 63.5cm
c 1834? Possibly painted in Rome

24 Penry Williams
1800-85
Swansea Town and Bay
Canvas 31.75 x 55.75in
81 x 142cm
c 1825

125 T Leigh
active 1643-1656?
Robert Davies
1616-1666
Canvas 28 x 23.125in
71 x 60cm
Signed and dated 1643. Robert Davies
was the husband of Anne Mytton; he was
the squire of Gwsaney, Mold.

126 Giuseppe Marchi
1736-1808
Rice Jones of Pencerrig
b. 1749
Canvas 25 x 24in
63.5 x 61.1cm
Signed and dated 1785. Rice Jones was the
younger brother of the painter Thomas
Jones who records that Marchi painted
portraits at Pencerrig in 1768.

It has already been implied that Welsh patronage, at least until 1800, was directed to London or abroad. As two early examples of the possible form this might take we may cite the Sir John Donne of Kidwelly Triptych painted by Memlinc in Bruges, c.1465, and the Withypoll Triptych painted by Antonio da Solario probably in Italy in 1514. (Withypoll's mother was from Cardiff, the daughter of John a Cant, whose coat of arms (quartered), appears on the verso of one of the wings). In the eighteenth century Sir Watkin Williams Wynn was a notable patron of Wilson and Sandby, and he financed the Welsh pupil of Reynolds, William Parry (1742-1791), on a trip to Italy. George Wynne is thought to have financed the young Wilson's first trip to London in 1729. As a collector of old masters within the convention of eighteenth-century taste we may mention Lord Cawdor of Stackpole Court, Pembrokeshire. Thomas Johnes of Hafod should also be mentioned both as a collector and as a patron — particularly of Thomas Banks and Stothard.

Few portrait painters were ever called to Wales, for the reasons already discussed. The earliest evidence of a visit seems provided by a Bardic portrait of Sion Kent, thought to be by a Flemish or English artist. Apart from this problem of origin the portrait suggests the existence of a series of Bardic portraits. There is some evidence for the visits of Edward Bellin in 1636 and Leigh in 1643. These are very shadowy figures known only through their signatures. In the eighteenth century James Fellowes between 1740 and 1750, Henry Pickering in 1755-6, Giuseppe Marchi in and between 1768 and 1785, and William Parry in 1770 and 1791, all appear to have practised in Wales, but they can hardly be claimed as a distinguished party. Of the names listed here only two may be termed London-based, the others apparently operating from Chester or Liverpool.

It is possible that some Welsh patronage in the eighteenth century went to Ireland where Robert Hunter and Robert Home, for example, were quite fashionable portraitists.

127 Francis Place
1647-1728
Tenby
Wash drawing 7.25 x 21.5in
18.4 x 54.6cm
1678

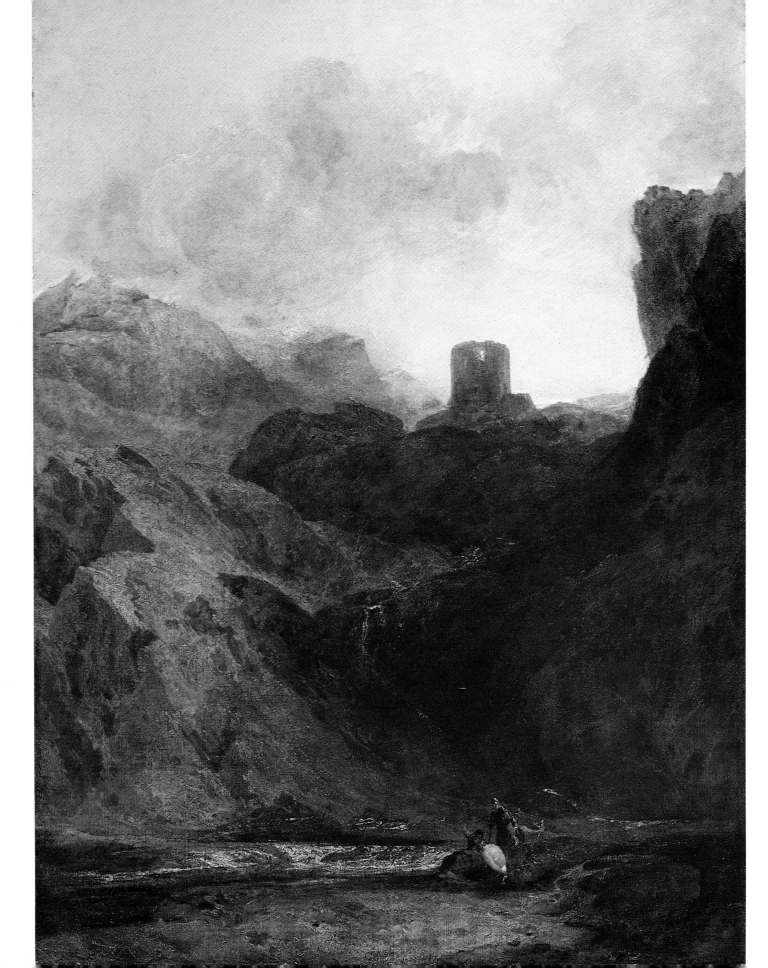

The Welsh Landscape

The best pictures of this period are undoubtedly those inspired by the Welsh landscape, which attracted painters, poets and essayists from around 1740 onwards. From Archbishop Herring, who wrote of Wales soon after 1740 that he had been *agreeably terrified with something like the rubbish of creation*, through Coleridge, who sat mystified in a ruined Welsh abbey listening to the music of a flute, there was an ever increasing interest taken in landscape and its effect on sensibility. The wild Welsh landscape offered a release from the finely calculated living of the time, and what started as a quest for raw nature soon became a fashionable excursion, hallowed by the Rev William Gilpin. Within Wales the three classifications of landscape, as then recognised by English aestheticians, were to be found; the sublime (the terrible, awesome view), the beautiful (the calm and pleasing) and the picturesque (the rustic variety or *rugged* aspect, of a landscape).

Landscape painting grew out of the topography of artists like Place and Buck, who in turn were doubtless inspired by the Anglo-Saxon revivalists, such as Dugdale, who directed new interest to the surviving castles and monuments of Great Britain.

129 Thomas Rowlandson
1757-1827
Pillar of Eliseg near Valle Crucis
Pen and wash 5.25 x 8in
13.3 x 20.3cm
1797

130 J C Ibbetson
1759-1817
Penillion Singing near Conway
Watercolour 8⅞ x 11½in
22.5 x 29.2cm
1792

128 J M W Turner
1775-1851
Dolbardarn Castle
Canvas 47 x 35.5in
119 x 90cm
1799. Diploma work submitted to the Royal Academy on Turner's election as an ARA in 1799. Based on drawings made in 1798 or 1799.

131 John Sell Cotman
1782-1842
Tan y Bwlch
Watercolour 8½ x 12½ in
21.6 x 31.8cm
c 1824

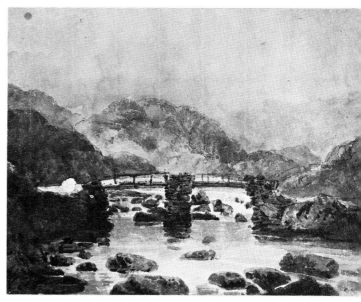

132 Thomas Girtin
1775-1802
Near Beddgelert
Watercolour 11.5 x 17 in.
29.2 x 43.2cm

133 J M W Turner
1775-1851
Hafod House
Watercolour 24 x 36½ in
61 x 92.7cm
1798. Hafod House was built for Thomas Johnes, 1748-1816, to the design of Thomas Baldwin of Bath in 1785. It was damaged by fire in 1807 but was rebuilt. Johnes planted over two million trees in the surrounding wasteland.

A fair selection of the oils and watercolours of the Welsh landscape painted by subsequent visiting artists is virtually impossible. With the exception of Constable, practically every significant name in the history of British landscape painting may be included. An attempt has been made to include those painters whose contribution was of the highest quality. Many of the artists came to Wales as companions of a distinguished traveller; Grimm came with Wyndham in 1777, Rowlandson with Henry Wigstead in 1797, and Ibbetson with Greville in 1792. Their work is consciously aimed at illustration, rather than at interpretation.

Rowlandson and Ibbetson stand rather apart from other visitors owing to their concern with, and interest in, the Welsh people. Wigstead's Tour is similarly concerned with the Welsh, fully as much as with their country; it would appear that he preferred the landscape because of the *dirtiness, everywhere apparent* which he found amongst the people. This may be the place to remark that it was largely the geography of Wales that had brought about this poverty, as well as the influx of English Milords. Two works of Rowlandson merit reflection; the aquatint of *The Artist in Wales* showing that romantic landscape was not the only emotional experience in store for the traveller, and *The Eliseg Monument*, which resumes much of the ground covered by this survey.

34 Edward Pritchard
1809-1905
Crossing the sands of Swansea Market
Canvas 29 x 50.25in
73.6 x 138cm
Signed *c.* 1855.

In the nineteenth century Cotman, Turner, Girtin and Cox could obscure the locality of a landscape with their interpretation of it. The rain which falls on Rowlandson as he travels through Wales will often obscure the peak of Cader Idris, and this the later painters recounted. Their concern with atmosphere and visual fact has since been equalled only by the impressionists. It is interesting to compare Cox's *On Rhyl Sands* with Pritchard's *Crossing the Sands to Swansea Market*. The subject of each picture is an open landscape, and each was painted in 1855. Pritchard, an unpretentious and able artist from Bristol, is concerned with narrating Welsh customs, while Cox contends magnificently with the weather.

John Ingamells

135 Thomas Rowlandson
1757-1827
The Artist travelling in Wales
Coloured aquatint 13 x 15.25in
33 x 36.7cm
Engraved by Merke, published in 1799. A
self-portrait of Rowlandson.

136 David Cox
1783-1859
On Rhyl Sands
Canvas 29.25 x 53.25in
74.3 x 135cm
Signed and dated 1854-5. Possibly re-touched by
his pupil Charles Burt.

BIBLIOGRAPHY

Pre Celtic and Celtic Period

BOON, G.C. and SAVORY, H.N. 'A Silver Trumpet-brooch with Relief Decoration, Parcel-Gilt, from Carmarthen, and a note on the Development of the Type', *Antiquaries Journal*, 55 (1975), 41-61.

FOSTER, I.Ll. and DANIEL, G. (Eds.). 'Celtic Art in Prehistoric Wales (c.300BC-400AD)', *Prehistoric and Early Wales*, London, 1965.

FOX, Sir C.F. *Pattern and Purpose*, Cardiff, 1958.

GRIMES, W.F. *Prehistory of Wales*, Cardiff, 1951.

JACOBSTHAL, P. *Early Celtic Art*, Oxford University Press, 1944, reprinted 1969.

JOPE, E.M. 'The Beginnings of La Tène Ornamental Style in the British Isles', *Problems of the Iron Age in Southern Britain*, S.S. Frere (ed.), London, 1960.

LEEDS, E.T. *Celtic Ornament in the British Isles down to A.D. 700*, Oxford University Press, 1933.

MEGAW, J.V.S. *Art of the European Iron Age*, Bath, 1970.

SANDARS, N.K. *Prehistoric Art in Europe*, Harmondsworth, 1968, chapters VII-IX.

SAVORY, H.N. 'A New Hoard of La Tène Metalwork from Merioneth', *Bulletin of the Board of Celtic Studies* 20.4, University of Wales Press (1964), 449-75; 'Further notes on the Tal-y-llyn (Mer.) Hoard of La Tène Metalwork', ib., 22 (1966), 88-102. *Early Iron Age Art in Wales*, Cardiff, 1968.

The Roman Occupation

FRERE, S. *Britannia*, Routledge & Kegan Paul, 1967.

POBE, M. and ROUBIER, J. *The Art of Roman Gaul*, Gallery Press, 1961.

RICHMOND, I.A. *Roman Britain*, Penguin Books, revised ed. 1963.

TOYNBEE, J.M.C. *Art in Britain under the Romans*, Oxford University Press, 1964.

Early Christian Wales

ALCOCK, Leslie. *Arthur's Britain: History and Archaeology A.D. 367-634*, Allen Lane the Penguin Press, 1971.

ALLEN, J. Romilly. *Early Christian Symbolism in Great Britain and Ireland* (the Rhind Lectures in Archaeology for 1885), London: Whiting & Co., 1887.

CHADWICK, Nora K. *Celtic Britain*, London: Thames & Hudson, 1963.

COLLINGWOOD, W.G. *Northumbrian Crosses of the Pre-Norman Age*, London: Faber & Gwyer, 1927.

CRUDEN, Stewart. *The Early Christian & Pictish Monuments of Scotland*, Edinburgh: H.M.S.O., 1957.

CUBBON, A.M. *The Art of the Manx Crosses*, Douglas, 1971.

DE PAOR, Maire and Liam. *Early Christian Ireland*, London: Thames & Hudson, 1958.

GRABAR, André. *Christian Iconography: a Study of its Origins* (The A.W. Mellon Lectures in the Fine Arts 1961), Routledge & Kegan Paul, 1969.

HENRY, Françoise. *Early Christian Irish Art*, Dublin, 1954.

HENRY, Françoise. *Irish High Crosses*, Dublin, 1964.

KENDRICK, T.D. *Anglo-Saxon Art to A.D. 900*, London: Methuen, 1938.

KENDRICK, T.D. *Late Saxon and Viking Art*, London: Methuen, 1949.

LANGDON, Arthur G. *Old Cornish Crosses*, Truro: Joseph Pollard, 1896.

MOORE, Donald. *Monuments of Early Christianity in Wales*, Cardiff: National Museum of Wales, 1972.

NASH-WILLIAMS, V.E. *Early Christian Monuments of Wales*, Cardiff: University of Wales Press, 1950.

ORDNANCE SURVEY. *Britain before the Norman Conquest* (text and map), Southampton, 1973.

RICHARDS, Melville. 'The Lichfield Gospels (Book of Saint Chad)', *The National Library of Wales Journal*, XVIII, No. 1 Summer 1973, 135-146.

SCRIVINER, F.H.A. *Codex S. Ceaddae Latinus Lichfieldensis edente cum prolegomenis etc.*, Cantab, 1887.

STEVENSON, R.B.K. 'Pictish Art', *The Problem of the Picts*, Edinburgh, 1955.

THOMAS, Charles. *Britain and Ireland in Early Christian Times, A.D. 400-800*, London: Thames & Hudson, 1971.

THOMAS, Charles. *The Early Christian Archaeology of North Britain*, Oxford University Press, 1971.

VAN DER MER, F. *Early Christian Art*, London: Faber and Faber, 1967.

VOLBACH, W.F. and HIRMER, Max. *Early Christian Art*, London: Thames & Hudson, 1961.

WILSON, David M. and KLINDT-JENSEN, Ole. *Viking Art*, London: George Allen & Unwin, 1966.

The Medieval Period

GARDNER, Arthur. *English Medieval Sculpture*, Cambridge, 1951.

GRESHAM, Colin. *Medieval Stone Carving in North Wales*, Cardiff: University of Wales Press, 1968.

LEWIS, Mostyn. *Stained Glass in North Wales up to 1850*, Altrincham, 1970. *Ancient Monuments of Wales*, H.M.S.O., 1973.

RICKERT, Margaret. *Painting in Britain; the Middle Ages*, Pelican Books, 1954.

STONE, Lawrence. *Sculpture in Britain; the Middle Ages*, Pelican Books, 1955.

WILLIAMS, Glanmor. *The Welsh Church from Conquest to Reformation*, Cardiff: University of Wales Press, 1962, revised 1976.

Painting in Wales, 1500-1850

BELL, D. *The Artist in Wales*, London, 1957.

CONSTABLE, W.G. *Richard Wilson*, London, 1953.

FRASER JENKINS, A.D. *The Romantic Traveller in Wales*, National Museum of Wales, 1970.

HUGHES, P. 'Paul Sandby and Sir Watkin Williams-Wynn', *The Burlington Magazine*, Vol. 114, July 1972, 459-67.

STEEGMAN, J. *A Survey of Portraits in Welsh Houses*, 2 vols., Cardiff, 1957 and 1962.

WATERHOUSE, E.K. *Painting in Britain*, Pelican Books, 1953, revised 1969.

WILLIAMS, I.A. *Early English Watercolours*, London, 1952, reprint 1970.

ILLustRations

The University of Wales Press and the Welsh Arts Council wish to record their gratitude for permission to reproduce the following illustrations. Unless otherwise stated, all photographs have been provided by the owners of the objects illustrated.

PRE CELTIC AND CELTIC PERIOD

1 **Stone Axe Hammer,** c. 1800-1600BC, National Museum of Wales. Lit: *Archaeologia Cambrensis,* 1927, pp.387 ff. Photograph by Arthur Williamson.

2 **Pygmy Cup,** c. 1400-1200 BC, National Museum of Wales. Lit: *Archaeological Journal,* 1942, pp1ff.

3 **Gold Lunula,** c. 1600-1400 BC, British Museum. Lit: *Archaeologia Cambrensis,* 1935, pp.309-31 Photograph by Arthur Williamson.

4 **Long-necked "Beaker",** c.1800-1600 BC, National Museum of Wales. Lit: *Archaeologia Cambrensis,* 1930, pp.402-5.

5 **Fragmentary Bronze Hanging Bowl,** early 3rd Century BC, National Museum of Wales. Lit: *Antiquaries Journal,* 1926, pp.276-80; Fox, *Pattern and Purpose,* Cardiff, 1958, p.1.

6 **Wooden Bowl,** c.1000-800 BC, National Museum of Wales. Lit: Grimes, *Prehistory of Wales,* Cardiff, 1951, pp.84 ff; Hawkes, *Las Relaciones Atlanticas del Mundo Tartesico* in Tartessos y sus Problemas (Maluquer de Motes ed.) Barcelona, 1969, pp.185-97. Photograph by Arthur Williamson.

7 **Metalworker's Mould,** c.300-200 BC, National Museum of Wales. Lit: *Archaeologia Cambrensis,* Vol. CXXIII, 1974, pp.170-174.

8 **Fragmentary Bronze Shield Boss,** c.200-100 BC, National Museum of Wales. Lit: *Bulletin of the Board of Celtic Studies,* XX 1962-4, pp.452-4.

9 **Engraved Plaque from Shield,** c.200-100 BC, National Museum of Wales. Lit: *Bulletin of the Board of Celtic Studies,* XX 1962-4, pp.454 f.

10 **Fragmentary Brass Shield-Boss,** c.200-100 BC, National Museum of Wales. Lit: *Bulletin of the Board of Celtic Studies,* XX 1962-4, pp.453-6.

11 **Bronze Plaque,** c.150-50 BC, National Museum of Wales. Lit: Fox, *A Find of the Early Iron Age from Llyn Cerrig Bach, Anglesey,* Cardiff, 1946, pp.46-53; Fox, *Pattern and Purpose,* Cardiff, 1958, p.33, fig.18, pl.23a. Photograph by Arthur Williamson.

12 **Bronze Shield Boss,** c.150-50 BC, National Museum of Wales. Lit: Fox, *A Find of the Early Iron Age from Llyn Cerrig Bach, Anglesey,* Cardiff, 1946, pp.7-11; Fox, *Pattern and Purpose,* Cardiff, 1958, pp.43-4, figs.28-31.

13 **Composite Plaque,** c.100-1 BC, National Museum of Wales. Lit: *Bulletin of the Board of Celtic Studies,* XX 1962-4, pp.463-8.

14 **Brass Openwork Plaque,** c.100-1 BC, National Museum of Wales. Lit: *Bulletin of the Board of Celtic Studies,* XX 1962-4, pp.463-8.

15 **Copy of a Bronze Plaque,** c.100-1 BC, National Museum of Wales. Lit: *Archaeologia Cambrensis,* 1928, pp.253-68; Fox, *Pattern and Purpose,* Cardiff, 1958, p.117, pl.45b.

16 **Trapezoid Plaque with Masks,** c.150-50 BC, National Museum of Wales. Lit: *Bulletin of the Board of Celtic Studies,* XX 1962-4, pp.461-3.

17 **Human Mask of Stone,** c.150 BC-50 AD, National Museum of Wales. Lit: *Amgueddfa,* 14, 1973, pp.28-34.

18 **Wooden and Bronze Tankard,** c.100-1 BC, Liverpool Museum. Lit: *Archaeologia Cambrensis,* 1896, pp.212-9; Fox, *Pattern and Purpose,* Cardiff, 1958, pp.109-10, pl.64. Photograph by Arthur Williamson.

19 **Part of a Bronze Collar,** c.50 BC-50 AD, The City Museum, Bristol. Lit: *Archaeologia Cambrensis,* 1901, pp.83-4; Fox, *Pattern and Purpose,* Cardiff, 1958, p.106, pl.12d. Photograph by Arthur Williamson.

20 **Bronze Ox Head,** c.50-150 AD, National Museum of Wales. Lit: *Archaeologia Cambrensis,* 1913, pp.191-8; Gardner and Savory, *Dinorben,* Cardiff, 1965, pp.144-8, fig. 20, pl.XXXV (a). Photograph by Arthur Williamson.

21 **Wrought-iron Fire-dog,** c.1-50 AD, National Museum of Wales. Lit: *Archaeologia Cambrensis,* 1856, pp.91 ff; *Antiquaries Journal,* 1939, pp.446 ff. and Boardman, Brown and Powell eds., *The European Community in Later Prehistory,* pp.251-3. Photograph by Arthur Williamson.

22 **Enamelled Bronze Terret,** c.1-50 AD, National Museum of Wales. Lit: *Archaeologia Cambrensis,* 1966 pp.27-44.

23 **Harness Fittings and Tankard Handles,** c.1-50 AD, National Museum of Wales. Lit: *Archaeologia Cambrensis,* 1905, pp.127-46; Fox, *Pattern and Purpose,* Cardiff, 1958, pp.127-9, fig.78, pl.66a,b.

24 **Bronze Cow Head,** c.50-150 AD, National Museum of Wales. Lit: Boon, *Antiquaries Journal,* 1961, pp.25 f, pl.X.

25 **Bronze Cow Head,** c.200-300 AD, National Museum of Wales. Lit: Gardner and Savory, *Dinorben,* Cardiff, 1965, pp.144-8, fig.21, pl.XXXIV (a).

26 **Base-plate for a Bronze Saucepan,** c.200-300 AD, National Museum of Wales. Lit: *Archaeologia Cambrensis,* 1901, pp.20-38; Wainwright, *Coygan Camp,* Cardiff, 1967, pp.85-88, fig.22.

27 **Reconstruction of silver, parcel-gilt Trumpet Brooch,** c.25-50 AD, National Museum of Wales. Lit: Boon and Savory, *Antiquaries Journal,* Vol. LV, 1975, pp.41-61.

28 **A Bronze Penannular Brooch,** c.50-150 AD, Private Collection. Lit: *Bulletin of the Board of Celtic Studies,* XIV, 1950-2, p.174 f, pl.II.2. Photograph, National Museum of Wales.

29 **A Pattern for a Penannular Brooch,** c.450-600 AD, National Museum of Wales. Lit: Alcock, *Dinas Powys,* Cardiff, 1963, pp.120-2, fig.23.2.

30 **A Fragmentary Penannular Brooch,** c.250-350 AD, Royal Institution of South Wales, Swansea. Lit: Savory, in *Dark Age Britain,* (ed. Harden), London, 1956, pp.42-51, fig.11.2.

Photograph, National Museum of Wales.

31 **Part of a Gilt Bronze Brooch,** c.1-100 AD, National Museum of Wales. Lit: Fox, *Pattern and Purpose,* Cardiff, 1958, pp.107-8, pl.41.

32 **A Bronze Trumpet Brooch,** c.50-150 AD, Private Collection. Lit: Boon, *Archaeologia Cambrensis,* 1968, p.44, fig.8.4. Photograph National Museum of Wales.

33 **Bronze Penannular Brooch,** c.400-600 AD, Newport Museum and Art Gallery. Lit: Savory, in *Dark Age Britain,* (ed. Harden), London, 1956, pp.43,47, pl.Vg.

THE ROMAN OCCUPATION

34 **Stone Carving of a Mother Goddess,** 1st-4th century AD, Newport Museum and Art Gallery. Lit: V.E. Nash-Williams, *Bulletin of the Board of Celtic Studies,* 1954, pp.88-9, pl.V; A. Ross, *Pagan Celtic Britain,* London, 1967, p.192, 207. Photograph by Arthur Williamson.

35 **Fragment of Samian Ware,** c.100-120 AD, National Museum of Wales. Lit: V.E. Nash-Williams, *Archaeologia Cambrensis,* LXXXVII, 1932, fig. 48,4. Photograph by Arthur Williamson.

36 **Part of a Decorated Samian Bowl,** 65-80 AD, National Museum of Wales.

37 **Samian Ware Cup,** Early 2nd century AD, National Museum of Wales.

38 **Gold Snake Bracelet with Gem,** 2nd-3rd century AD, British Museum.

39 **Gold Snake Bracelet,** 2nd-3rd century AD, British Museum. Lit: J.W. Brailsford, *Guide to the Antiquities of Roman Britain,* British Museum, London, 1964, p.13; V.E.

Nash-Williams, *Bulletin of the Board of Celtic Studies,* 1950, pp.81-2.

40 **Four Gold Rings,** 3rd-4th century AD, British Museum. Lit: R.A. Smith, *Guide to the Antiquities of Roman Britain,* British Museum, London, 1922, pp.65-6, fig.82; F.H. Marshall, *Catalogue of Finger-rings,* British Museum, 1907 and 1968, nos. 203, 544, 796, 797.

41 **Gold Ear-ring,** late 2nd century AD, National Museum of Wales.

42 **Iron Ring with Gem,** 2nd century AD, National Museum of Wales. Lit: V.E. Nash-Williams, *Archaeologia Cambrensis,* LXXXVII, 1932, pp.93-4, fig.41; M. Henig, *A Corpus of Roman Engraved Gemstones from British Sites,* British Archaeological Reports 8, 1974, no.289. Photograph by Arthur Williamson.

43 **Gold "Crossbow" Brooch,** 3rd-4th century AD, Caernarvon Royal Borough Council. Lit: R.E.M. Wheeler, *Segontium and the Roman Occupation of Wales,* Cardiff, 1924, pp.130-1; G.C. Boon, *Bulletin of the Board of Celtic Studies,* XXI 1964-5, pp.97-98. Photograph by Arthur Williamson.

44 **Bronze Jug,** 1st century AD, Welshpool Borough Council. Lit: G.C. Boon, *Antiquaries Journal,* XLI, 1961, pp.20-22; J.M.C. Toynbee, *Art in Roman Britain,* London, 1962, Cat. No.117, pl.133; J.M.C. Toynbee, *Art in Britain under the Romans,* Oxford, 1964, pp.324-5, pl.LXXIV b. Photograph by Arthur Williamson.

45 **Gold Ring with Engraved Stone,** 2nd-3rd century AD, National Museum of Wales. Photograph by Arthur Williamson.

46 **Bronze Patera,** 1st century AD, National Museum of Wales.

47 **Bronze Stud with Enamelled Decoration,** 2nd century AD, National Museum of Wales. Lit: J.E. Lee, *Isca Silurum*, 1862, p.56, pl.28,14. Photograph by Arthur Williamson.

48 **Bronze Stud with Enamelled Decoration,** 2nd century AD, British Museum. Lit: J.W. Brailsford, *Guide to the Antiquities of Roman Britain,* British Museum, London, 1964, p.56, pl.XXI.

49 **Bronze Dodecahedron,** 2nd-4th century AD, British Museum. Lit: J.W. Brailsford, *Guide to the Antiquities of Roman Britain,* British Museum, London, 1964, p.78, fig.40,5; F.H. Thompson, *Antiquaries Journal,* L 1970, pp.93-6.

50 **Stone Statue of Fortuna,** 2nd-3rd century AD, National Museum of Wales. Lit: A.H.A. Hogg, *Britannia V,* 1974, pp.242-4, pl.XXa.

51 **Painted Wall-Plaster,** 2nd century AD, Newport Museum and Art Gallery.

52 **Labyrinth Mosaic,** 3rd century AD, National Museum of Wales. Lit: G.C. Boon, *Isca,* Cardiff, 1962; D. Smith, *Bulletin of the Board of Celtic Studies,* XIX, pp.304-310.

53 **Fragment of Mosaic Pavement,** 4th century AD, Newport Museum and Art Gallery. From a reconstruction in Archaeologia LVIII; reproduced by permission of the Society of Antiquaries of London. Lit: *Archaeologia LVIII,* 1902, pl.10.

54 **Inscription on Stone,** 198-209 AD, National Museum of Wales (Caerleon Museum). Lit: R.E.M. Wheeler, *Prehistoric and Roman Wales,* Oxford, 1925, p.233; R.G. Collingwood and R.P. Wright, *The Roman Inscriptions of Britain,* Vol.I. Oxford, 1965, no.333.

55 **Inscription on Stone,** 100 AD, National Museum of Wales (Caerleon Museum). Lit: *Journal of Roman Studies,* XVIII, 1928, p.210, fig.71; V.E. Nash-Williams, *Archaeologia Cambrensis,* LXXXIV, 1929, p.142, fig.4; R.G. Collingwood and R.P. Wright, *The Roman Inscriptions of Britain,* Vol.I. Oxford, 1965, no.330.

56 **Stone Relief Sculpture,** 2nd-3rd century AD, National Museum of Wales. Lit: V.E. and A.H. Nash-Williams, *Catalogue of the Roman Inscribed Stones found at Caerleon,* Cardiff, 1935. no.95.

57 **Inscription on Stone,** 255-260 AD, National Museum of Wales (Caerleon Museum). Lit: J.E. Lee, *Isca Silurum,* London, 1862, p.12, pl.V,i; R.G. Collingwood and R.P. Wright, *The Roman Inscriptions of Britain,* Vol.I. Oxford, 1965. no.334.

58 **Ivory Mount,** 2nd-3rd century AD, National Museum of Wales .Lit: J.E. Lee, *Isca Silurum,* London, 1862, pp.59-60, pl.29; J.M.C. Toynbee, *Art in Britain under the Romans,* Oxford, 1964, p.359, pl.LXXXIIa. Photograph by Arthur Williamson.

59 **Agate Cameo,** 1st Century AD, National Museum of Wales. Photograph by Arthur Williamson.

60 **Gold Necklet or Bracelet,** 2nd-3rd century AD, British Museum. Lit: F.H. Marshall, *Catalogue of Jewellery,* British Museum, London 1911 and 1969, no.2798-9.

61 **Ivory Mount,** 2nd-3rd century AD, National Museum of Wales. Lit: J.E. Lee, *Isca Silurum,* London, 1862, pp.59-60. pl.29; J.M.C. Toynbee, *Art in Britain under the Romans,* Oxford, 1964, p.359, pl.LXXXII b. Photograph by Arthur Williamson.

62 **Silver Standard-head,** 2nd-3rd century AD, National Museum of Wales. Lit: V.E. Nash-Williams, *The Roman Legionary Fortress at Caerleon,* Cardiff, 1952, p.18, pl.6b; G.C. Boon, *Isca* Cardiff, 1962, pl.9b. Photograph by Arthur Williamson.

63 **Pottery face-urn,** 2nd-3rd century AD, National Museum of Wales. Lit: V.E. Nash-Williams, *Archaeologia* LXXX 1930, p.250. Photograph by Arthur Williamson.

64 **Bronze Statuette of Mercury,** 2nd-3rd century AD, National Museum of Wales. Lit: R.E.M. and T.V. Wheeler, *Archaeologia,* LXXVIII, 1928, p.161, pl.32. Photograph by Arthur Williamson.

65 **Fragment of Glass Bottle,** 3rd-4th century AD, National Museum of Wales. Lit: G.C. Boon, *Journal of Glass Studies,* X, 1968, pp.80-84.

66 **Glazed Pottery Beaker,** 1st century AD, National Museum of Wales. Lit: G. Dunning, *Bulletin of the Board of Celtic Studies,* 1950, p.56. Photograph by Arthur Williamson.

67 **Gold Bracelet,** 2nd-3rd century AD, British Museum. Lit: *Archaeologia Cambrensis,* XVI 1899, pp.259-267; F.H. Marshall, *Catalogue of Jewellery,* British Museum, London, 1911 and 1969, no.2797.

68 **Pottery Antefix,** 2nd century AD, British Museum. Lit: W.F. Grimes, Holt, Denbighshire; *the Works-Depot of the Twentieth Legion at Castle Lyons, Y Cymmrodor, XLI,* 1930, p.210.

69 **Pottery Bottle,** early 2nd century AD, National Museum of Wales. Lit: W.F. Grimes, Holt, Denbighshire; *the Works-Depot of the Twentieth Legion at Castle Lyons, Y Cymmrodor, XLI,* 1930, p.157, fig.67,118.

70 **Pottery Poinçon,** 2nd century AD, National Museum of Wales. Lit: W.F. Grimes, Holt, Denbighshire; *the Works-Depot of the Twentieth Legion at Castle Lyons, Y Cymmrodor, XLI* 1930, p.130, fig.57,4; D.M. Bailey, *The Manufacture of Roman Pottery Lamps,* in D. Brown and D.E. Strong (ed.), *Roman Crafts,* 1975.

EARLY CHRISTIAN WALES

71 **The Gospels of St. Chad,** (page 220) Dean and Chapter, Lichfield Cathedral.

72 **The Cross of Conbelin (Cynfelyn),** late 9th - early 10th century, Margam Museum, West Glamorgan. Lit: V.E. Nash-Williams, *The Early Christian Monuments of Wales,* Cardiff, 1950, no.234. Photograph, National Museum of Wales.

73 **Early Christian Finds from Wales: Pottery and Hand-bells..**
Bowl of grey ware 450-650
Bowl of red ware, probably 5th century.
St. Gwynhoedl's bell, 9th-11th century.
St. Ceneu's bell.
National Museum of Wales.

74 **The Cross of Grutne,** late 9th - early 10th century, Margam Museum. Lit: V.E. Nash-Williams, op. cit., no.233. Photograph, National Museum of Wales.

75 **The Gravestone of Ulcagnus,** 5th - early 6th century, in Llanfihangel-ararth Churchyard, Ceredigion. Lit: V.E. Nash-Williams, op. cit., no.157. Photograph, National Museum of Wales.

76 **The Gravestone of King Cadfan of Gwynedd,** c.625, in Llangadwaladr Church, Anglesey. Lit: V.E. Nash-Williams, op. cit., no.13. Photograph, National Museum of Wales.

77 **Gospels of St. Chad,** (page 221) Dean and Chapter, Lichfield Cathedral.

78 **Ring-cross, St. Non's Chapel,** 5th-7th century, St. Non's Chapel, St. David's, Dyfed. Lit: V.E. Nash-Williams, op. cit., no.372. Photograph, National Museum of Wales.

79 **A Cross at Llanfihangel Cwm Du** possibly 7th - 9th century, Llanfihangel Cwm Du, Brecknock. Lit: V.E. Nash-Williams, op. cit., no.54a. Photograph, National Museum of Wales.

80 **The Pen-y-fai Cross,** late 10th or 11th century, National Museum of Wales. Lit: *Archaeologia Cambrensis, 1970,* pp.71-74.

81 **The Stone of Anatemor,** 5th - early 6th century, Llanfaglan Church, Gwynedd. Lit: V.E. Nash-Williams, op. cit., no.89. Photograph, National Museum of Wales.

82 **The Cross of Houelt,** late 9th century, Llantwit Major Church, South Glamorgan. Lit: V.E. Nash-Williams, op. cit., no.220. Photograph, National Museum of Wales.

83 **Cross at Penmon,** late 10th-11th century, Penmon Church, Anglesey. Lit: V.E. Nash-Williams, op. cit., no.37. Photograph, National Museum of Wales.

84 **The Eglwysilan Warrior,** possibly 7th-9th century, Eglwysilan Church, Mid Glamorgan. Lit: V.E. Nash-Williams, op. cit., no.195. Photograph, National Museum of Wales.

85 **Cross at Nevern,** late 10th - early 11th century, Nevern churchyard. Lit: V.E. Nash-Williams, op cit., no.360. Photograph, National Museum of Wales.

86 **Cross at Penally,** first half of 10th century, Penally Church, Dyfed. Lit: V.E. Nash-Williams, op. cit., no.364. Photograph, National Museum of Wales.

87 **The Llangan Crucifixion,** 10th-11th century, Llangan Churchyard, Mid Glamorgan. Lit: V.E. Nash-Williams, op. cit., no.207. Photograph, National Museum of Wales.

88 **The Briamail Flou Cross-slab,** late 10th century, Llandyfaelog Fach Churchyard, Brecknock. Lit: V.E. Nash Williams, op. cit., no.49. Photograph, National Museum of Wales.

89 **The Cefn Hirfynydd Figure,** 9th-10th century, Royal Institution of South Wales, Swansea. Lit: V.E. Nash-Williams, op. cit., no.269. Photograph, National Museum of Wales.

90 **Early Christian Brooches from Wales:** left to right —
Bronze pin with square head.
Bronze pin with pair of involuted spirals.
Bronze ring-headed pin.
Bronze penannular brooch.
Silver penannular brooch, with admixture of copper.
Part of bronze 'thistle' brooch of Irish type.
National Museum of Wales.

91 **Early Christian Objects from Wales:** Silver Viking armlet.
Basalt whetstone carved in form of girl's head (with pigtail at back), 7th-9th century.
National Museum of Wales; original of Whetstone in British Museum.

92 **The Gospels of St Chad showing the evangelist Luke** (page 218 of manuscript) Dean and Chapter, Lichfield Cathedral.

93 **A Page of Text from the Gospels of St. Chad,** (page 117 of manuscript), Dean and Chapter, Lichfield Cathedral.

THE MEDIEVAL PERIOD

94 **Effigy of a Knight,** late 13th century, St. Mary's Parish Church, Abergavenny. Lit: O. Morgan, *Abergavenny Monuments,* Newport, 1872, pp.21-3, pl.1; *Cambrian Arch. Assoc., Abergavenny,* 1936, pp.354,356, illus. p.351; A. Gardner, *English Medieval Sculpture,* Cambridge, 1951, pl.427. Photograph by Julian Shepherd.

95 **Carved Stone-work,** early 13th century. **Capital of a corbel shaft with stylised floral detail.** Photograph, Arthur Williamson. **Corbel stone with carved human head,** the lower half restored. Col. J.F. Williams-Wynne, D.S.O., and the National Museum of Wales. Photograph, Arthur Williamson.

96 **Pen Arthur Farm Slab,** 9th-10th century, National Museum of Wales. Lit: V.E. Nash-Williams, *The Early Christian Monuments of Wales,* Cardiff, 1950, no.374.

97 **Jesse Window,** 1533. Parish Church of Llanrhaeadr Dyffryn Clwyd. Photograph by Mostyn Lewis.

98 **Caernarvon Book of Hours,** 14th century, National Library of Wales. Photograph by Arthur Williamson.

99 **Rood figure of Christ,** 14th century, Monmouthshire and Caerleon Antiquarian Association and the National Museum of Wales. Lit: *Archaeologia Cambrensis,* 1886, pp.282 ff. Photograph by Arthur Williamson.

100 **Tintern Abbey, Gwent,** 13th century, Crown copyright, reproduced with permission of the Controller of Her Majesty's Stationery Office.

101 **Wrexham Church Tower,** before 1518, photograph from the D. Leslie Davies Collection, from an original engraving of 1824, probably by Willoughby Raimond.

102 **Bishop's Palace, St. David's,** 14th century, Lit: Fox, *South Wales (Regional Guides of Ancient Monuments, Vol. IV),* London, 1938, p.54, fig.14. Crown copyright, reproduced with the permission of the Controller of Her Majesty's Stationery Office.

103 **Part of Conway Church screen,** late 15th century, Lit: *Royal Commission for Ancient Monuments, Caernarvonshire, Vol.1,* London, 1953, p.45b, pl.30,31. Crown copyright, reproduced with permission of the Controller of Her Majesty's Stationery Office.

104 **Sleeping Jesse,** late 14th - early 15th century, St. Mary's Parish Church, Abergavenny. Lit: O. Morgan, *Abergavenny Monuments,* Newport, 1872, pp.85-7, pl.xii. Photograph by Julian Shepherd.

105 **St. David's Chalice,** c.1280, St. David's Cathedral. Lit: J.T. Evans, *The Church Plate of Pembrokeshire,* London, 1905, pp.88-9, pl.1; Oman, *Archaeological Journal,* 1939, pp.160, 162(7).

106 **St. David's Cathedral Roof,** late 15th century, Lit: *Archaeologia Cambrensis,* 1922, p.440. Crown copyright, reproduced with permission of the Controller of Her Majesty's Stationery Office.

107 **Female effigy,** mid-16th century, Brecon Priory. Lit: A.C. Fryer, *Wooden Monumental Effigies in England and Wales,* London, 1924, pp.60-2, and 71(7), pl.XXVI, fig.59. Photograph by Arthur Williamson.

108 **Communion Cup,** c.1574, National Museum of Wales.

109 **Fresco detail showing St. Christopher,** early 16th century, Parish Church of Llantwit Major. From a water-colour interpretation by Eric Rowan. Photograph by Eric Rowan.

110 **Raglan Castle,** 15th and 16th centuries, Photograph by Eric Rowan.

111 **Dolgellau Chalice and Paten,** c.1250, (Electrotype copies), National Museum of Wales. Lit: Oman, *English Church,* Plate 597-1830, London, 1957, pp.41, 47-8, pls.4 and 25b.

PAINTING IN WALES, 1550-1850

112 **Moses Griffith,** 1747-1819, Pulpud Huw Llwyd o Gynfal near Ffestiniog, National Library of Wales.

113 **Thomas Horner,** active 1816-1823, The Rolling Mills at Dowlais, National Museum of Wales. Photograph by Arthur Williamson.

114 **William Roos,** 1808-1878, Christmas Evans 1766-1838, National Museum of Wales. Photograph by Arthur Williamson.

115 **Anonymous,** 1627, Jenkyn Williams 1548-c.1630, Col. Mervyn Williams. Photograph by Arthur Williamson.

116 **Richard Wilson,** 1713/4-1782, Valley of the Mawddach, City Art Gallery, Manchester.

117 **Richard Wilson,** 1713/4-1782, Pembroke Castle, National Museum of Wales.

118 **John Dyer,** 1699-1758, Caerphilly Castle, the late Professor A. Clutton-Brock. Photograph by Arthur Williamson.

119 **Francesco Renaldi,** active 1777-1798, Thomas Jones and his family, National Museum of Wales. Photograph by Arthur Williamson.

120 **Thomas Jones,** 1742-1803, The Bard, National Museum of Wales.

121 **Paul Sandby,** 1725/6-1809, West Gate Cardiff, National Museum of Wales.

122 **Thomas Jones,** 1742-1803, Extensive Landscape, Pencerrig, National Museum of Wales.

123 **Thomas Brigstocke,** 1809-1881, Self-Portrait, National Library of Wales. Photograph by Arthur Williamson.

124 **Penry Williams,** 1800-85, Swansea Town and Bay, National Museum of Wales.

125 **T. Leigh,** active 1643-1656?, Robert Davies 1616-1666, National Museum of Wales.

126 **Giuseppe Marchi,** 1736-1808, Rice Jones of Pencerrig, b.1749, Mrs. D.L. Corkery. Photograph with permission of National Museum of Wales.

127 **Francis Place,** 1647-1728, Tenby, National Museum of Wales.

128 **J.M.W. Turner,** 1775-1851, Dolbadarn Castle, Royal Academy of Arts, London.

129 **Thomas Rowlandson,** 1757-1827, Pillar of Eliseg near Valle Crucis, National Library of Wales.

130 **J.C. Ibbetson,** 1759-1817, Penillion Singing near Conway, National Museum of Wales.

131 **John Sell Cotman,** 1782-1842, Tan y Bwlch, City Art Gallery, Leeds. Photograph by Arthur Williamson.

132 **Thomas Girtin,** 1775-1802, Near Beddgelert, British Museum.

133 **J.M.W. Turner,** 1775-1851, Hafod House, Lady Lever Art Gallery, Port Sunlight.

134 **Edward Pritchard,** 1809-1905, Crossing the sands to Swansea Market, National Museum of Wales.

135 **Thomas Rowlandson,** 1757-1827, The Artist travelling in Wales, National Museum of Wales.

136 **David Cox,** 1783-1859, On Rhyl Sands, City Museum and Art Gallery, Birmingham.

CONTRIBUTORS

H N Savory:
Born 1911. Educated at Magdalen College School, Oxford and Oxford University (Lit.Hum. 1st Class, 1934 and D.Phil. 1937). MacIver student in Iberian Archaeology, Queens College, Oxford, 1936-8. Assistant Keeper in Archaeology, National Museum of Wales 1938-56, Keeper 1956-76 Specialised in later prehistory of Britain and western Europe, with many articles in *Proceedings of the Prehistoric Society, Archaeologia Cambrensis* and *Bulletin of the Board of Celtic Studies* concerning chance finds, and excavations in Neolithic and Bronze Age burial mounds and hillforts of Wales. Also *Dinorben Hillfort* (Cardiff 1964 and 1971) and *Spain and Portugal* (Thames & Hudson, 1968).

Catherine Johns:
Born in West Wales, brought up in London, and took her degree in Archaeology at University College, Cardiff. She spent three years working on provincial Roman pottery at a German museum, and is now on the staff of the Prehistoric and Romano-British Department of the British Museum. In 1973 she was elected a Fellow of the Society of Antiquaries.

Donald Moore:
Was on the staff of the National Museum of Wales, 1953-77, latterly as Senior Officer of the Schools Service and is now Keeper of Prints, Drawings and Maps at the National Library of Wales. He has written Museum publications on Early Christian monuments, Roman Caerleon and museum education. In 1971 he took part in producing an exhibition of replicas of Early Christian monuments of Wales, sponsored by the Welsh Arts Council at the National Eisteddfod of Wales in Bangor.

Glanmor Williams:
M.A., D.Litt., Native of Dowlais, Glamorgan. Educated at Cyfarthfa School and the University College of Wales, Aberystwyth. Professor of History, University College of Swansea since 1957. Author of many books and articles, including *The Welsh Church from Conquest to Reformation.* General Editor of the *Glamorgan County History*, Vol. III (1971) and IV (1974).

John Ingamells:
John Ingamells was Art Assistant at York Art Gallery from 1959 to 1962; Assistant Keeper, Department of Art, National Museum of Wales from 1963-1967 and since 1967 he has been Curator of the York Art Gallery.

Eric Rowan:
Artist Eric Rowan is a senior lecturer in the History of Art at the College of Art, Cardiff and a member of 56 Group Wales. Writes art criticism for various publications, including *The Times, The Western Mail, Studio International;* and also documentary scripts for BBC Television.

INDEX

(Numbers in italics refer to illustrations)